SECRET EASTBOURNE

Kevin Gordon

AMBERLEY

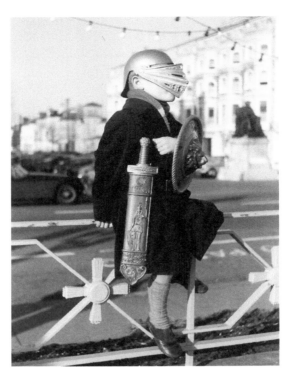

My brother on the seafront in 1967, protecting Eastbourne from any invaders!

I dedicate this book to my brother Andrew and his wife Sasha,
who have lived in Eastbourne all their lives.

First published 2018

Amberley Publishing
The Hill, Stroud
Gloucestershire, GL5 4EP

www.amberley-books.com

Copyright © Kevin Gordon, 2018

The right of Kevin Gordon to be identified as the
Author of this work has been asserted in accordance
with the Copyrights, Designs and Patents Act 1988.

ISBN 978 1 4456 7702 6 (print)
ISBN 978 1 4456 7703 3 (ebook)

British Library Cataloguing in Publication Data.
A catalogue record for this book is available from the
British Library.

Origination by Amberley Publishing.
Printed in Great Britain.

Contents

Introduction

I was born in Eastbourne; in fact, I was born in the same bed as the Prime Minister. Theresa May (then Theresa Mary Brasier) was born at Eastbourne Maternity Hospital, No. 9 Upperton Road, just a few months before me – and who can say it wasn't the same bed?

My family go back a long way in Eastbourne. My ancestors lived in the Old Town, a stone's throw from St Mary's Parish Church and in the Roselands area to the east of the town. My parents still live in Old Town and my brother Andrew still lives in Roselands.

Although I never knew him, my great-grandfather Ebenezer Roberts was quite a character. He was a God-fearing Baptist who preached at the chapel in Grove Road. He was a vehement Protestant who regaled local people with fiery speeches every 5 November as the head of the local Bonfire Society. Ebenezer was an amateur poet and sent many of his verses to Buckingham Palace, carefully keeping the polite acknowledgements. His daughter, Bessie, grew to be a strong and opinionated woman. She was a vocal Liberal who championed animal rights and was also a keen photographer.

Bessie married my grandfather, Alec, who was a quiet man. He had been seriously injured during the First World War – losing a leg – and had been recommended for a Victoria Cross. After the war, he retrained to be a picture framer and worked for the Stacy-Marks gallery in Terminus Road.

My father, Roger, worked on the railway and, due to his travel concessions, I was lucky enough to be taken on many trips to London to visit the annual Lord Mayor's Show and also the many museums. In 1972, I queued for hours to see the spectacular Tutankhamun Exhibition and was determined to be an archaeologist. I didn't get to Egypt but I did help on an archaeological dig opposite St Mary's Church, excavating the site of medieval buildings. My love of history had started.

Eastbourne was a good place to grow up. Saturday mornings were spent at the ABC Cinema where I was an ABC minor, cheering on the Lone Ranger or Flash Gordon. Warm, lazy summer afternoons were spent on the beach, and there were plenty of places to explore for an enquiring mind and rock pools to dip into. I remember a time when there were still bomb sites in the town. As a teenager I visited most of the town's pubs and clubs and spent a few evenings optimistically waiting for dates to turn up at the Southdown bus depot.

What exactly is the origin of Eastbourne? The local heritage manager, Jo Seaman, will tell you that the original Old Town was a rural village, surrounded by mills and farmland. My old friend Ted Hide, a respected marine historian, will tell you how the sea has given Eastbourne its lifeblood, whereas the Local Heritage Centre concentrates on the town in its heyday as a popular and vibrant seaside resort, brimming with civic pride. They are, of course, both correct.

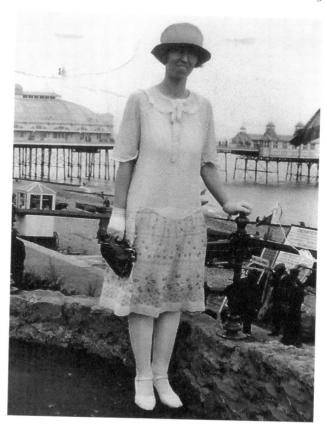

My grandmother Bessie near the pier, *c.* 1926.

With a population of over 100,000 people, Eastbourne is much larger than when I was young and it would be impossible to cover the whole town in this book. I have therefore concentrated on the two areas of the town I know well: the seafront and the Old Town.

The book takes the form of a long imaginary walk from the Crumbles to the Old Town. I have tried to tell stories of a secret Eastbourne known only to a handful of local historians; however, in my eyes it is not only buildings that are of interest but also the people who once knew the town as well as you or I, so I have included some interesting characters too. So, if you are keen to know about murders, goat taxis and bored saints, then read on.

1. The Crumbles to the Pier

The Lost Towers

In the eighteenth century the area to the east of Eastbourne was a wide lonely stretch of barren shingle. This was known as the Crombleland or the Crumbles. The origin of the name is uncertain, but it was first mentioned in the thirteenth century.

Being vulnerable to a French invasion, a series of Martello towers were built. Although the towers stretched around the south-east coast they tended to be quite isolated; however, here they were so close that a short stretch of shore was acquired to build

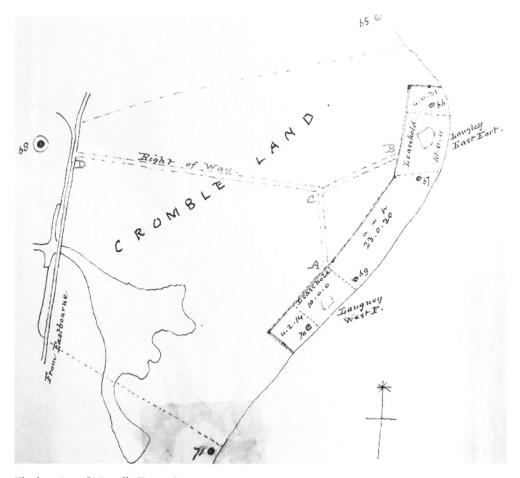

The location of Martello Tower 65–71.

four towers – Nos 66 to 70 – and two small forts, Langney East and Langley West – note the two different spellings for the same place!

Tower 66 still stands – alone near the entrance to the Sovereign Harbour. The other towers were victims of rising sea levels. Between 1810 and 1860 the sea had encroached by over 90 feet at Tower 69 and Tower 70, and by 40 feet at Tower 67. Finally they all succumbed to the sea.

Few people realise that there was a secret inland Martello tower here. The reason it was built behind the other defences can be traced back to the very first Martello tower in Corsica.

In 1763, a Corsican general requested assistance from the Royal Navy in ousting French revolutionaries who had taken a defensive tower at Mortella Point to the north of the island ('mortella' was the local name for myrtle bushes). HMS *Lowestoft* easily managed to take the tower, but a few months later it was recaptured. This time the French put up a show of force. HMS *Fortitude* (seventy-four guns) and HMS *Juno* (thirty-two guns) failed to take the tower, which returned fire. Sixty English sailors were injured and six were killed. In the end marines had to land four cannon and drag them to the rear of the tower, which had thinner walls, but even then it took two days to force the occupants to surrender. The British Army and Navy were so impressed with the design of the fort that they made detailed plans ... and then blew it up.

The Mortella tower in Corsica was the inspiration for the south-coast Martello towers, but they were still vulnerable to attack from the rear, which would be a problem at the Crumbles where the towers were so close together. The solution was to build a tower to protect their flank. Tower 68 was therefore built inland on the Eastbourne to Pevensey road. Although the Martello tower has long since gone, there is evidence of it when you look at a map. The circular streets named Rotunda Road and The Circus surround the site of the former tower.

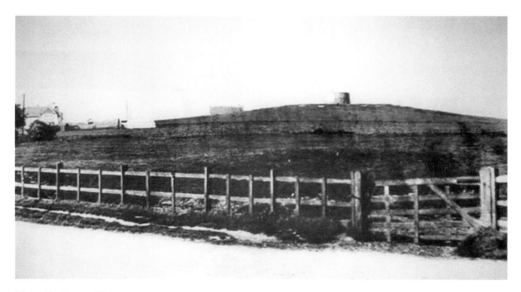

Martello Tower 68.

Murder!

The desolate stretches of shingle here hold another secret: two horrible murders took place in the 1920s. Further along the coast, at the isolated Coastguard Cottages, Patrick Mahon murdered his pregnant lover, Emily Beilby Kaye, in 1924. This sensational murder shocked the country and became known as the 'Crumbles Murder', but few realise that this was actually the second Crumbles murder; the first one happened just four years earlier.

Seventeen-year-old Irene Munro was a cheerful independent girl. Her job as a short-hand typist in Oxford Street, London, earned her enough money to take regular holidays. The previous year she had stayed in Brighton, but in August 1920 she arrived in Eastbourne and took lodgings in Seaside.

Irene enjoyed the fresh sea air and took many walks along the beach, west to Beachy Head and east to the Crumbles. She was pretty and wore a bright green coat so was noticed by several gentlemen who were later to become important witnesses. On 19 August she was seen walking towards the Crumbles, arm-in-arm with two men, one of them carrying a walking stick. Her battered and bruised body was found in a shallow shingle grave the next morning. The murder weapon, a bloodstained brick, was found nearby.

Two local men, William Gray and Jack Field, were quickly identified as suspects. Both men were unemployed and hung around the local bars and cinemas, and Field usually used a walking stick. Both were arrested as they tried to join the army. The suspects had a ready alibi: they were in Pevensey on the day of the murder in the company of a girl called Maud.

Maud was a maid and vehemently denied their story; she had been at work all day, a fact corroborated by her employers. In desperation, Field and Gray blamed each other for

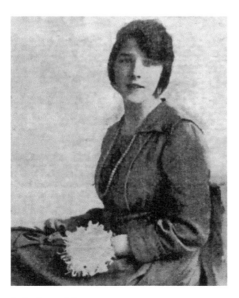

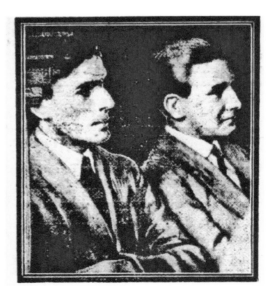

Left: Irene Munro.

Right: Field and Gray.

the killing, but despite there being no direct evidence to link them to the crime, they were both convicted. Perhaps the jury were unsure of the evidence as, although they found the two men guilty, they made a recommendation for mercy. This plea was ignored and the men were executed at Wandsworth Prison in February 1921.

A Ghost in the Works

Standing at the entrance to Sovereign Harbour, Tower 66 is the last remaining Martello tower before the Wish Tower. During the Second World War a concrete roof was added in order to take a gun emplacement, and above this there is now a rather ugly coastguard station. Members of Coastwatch, however, hope to improve the facilities to assist them with their important work.

Nearby is the Sovereign Water Treatment works, which opened in 1996. This well-designed building reflects the curves of the nearby Martello towers and the Redoubt Fort. It treats a staggering 86 million litres of water every day that is used by over 140,000 local people. During 2018, improvement works are taking place. As this work is underground and dangerous, fifty rescue workers are on hand to provide twenty-four-hour emergency rescue cover. Hopefully they will not encounter any ghosts as, unlikely as it may seem for a relatively new building, there are rumours that the place is haunted.

> **DID YOU KNOW?**
> The area around St Andrew's Church to the east of Eastbourne is called Norway. There were two routes towards Pevensey: the slow route via the Crumbles or the quicker north way – hence 'Norway'.

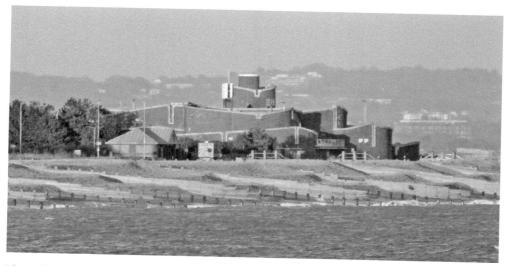

The well-designed Eastbourne Water Treatment Works.

The Tiny Tramline

One of my favourite treats as a young lad was a ride on one of Eastbourne's trams. The miniature-scale trams ran from a point near the present day Sovereign Centre to Princes Park. The first section of the 2-foot gauge line opened to the public on 15 August 1954 and it was extended to the Crumbles in May 1958. On both occasions, the mayor drove the first tram. The trams themselves were of a variety of designs – from an enclosed and rather modern-looking 'winter saloon' to several double-decker cars. It was great fun to sit on the small slatted seats with backs that could be moved so you were always facing the front. The trams would bump along the shingle with an occasional 'zizz' and spark from the electric pick-up arm.

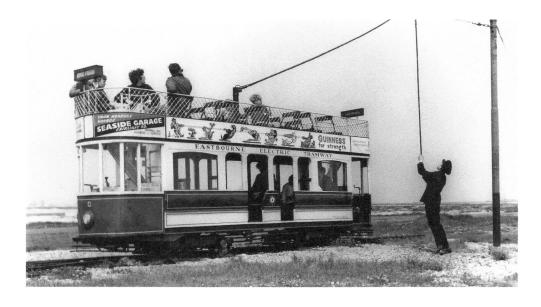

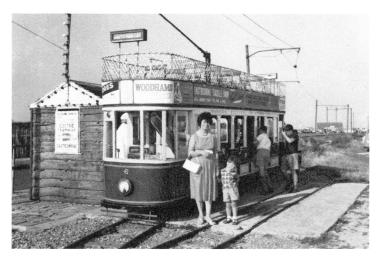

Above: Eastbourne tram No. 6.

Left: My mum and I with the No. 6 tram.

The service was popular and in 1962 there were over 200,000 passengers – not bad for a tramline that didn't really go anywhere! The 1960s saw plans by the council to improve roads in the area. A new home for the trams was found in Seaton, Devon, and on 14 September 1969 the line closed.

In the same area was another set of railway lines used by trains to remove shingle from the beach. This branch line curved around the back of what is now Tesco to the main line near the railway station. Sadly, none of the tracks remain.

Tower 71

Once the tramline would have afforded good views of Martello Towers 66 to 72, but these had long since fallen into the sea. Tower 71 suffered an ignoble fate when, in August 1860, it was used to test Sir William Armstrong's new gun.

In response to difficulties with artillery during the Crimean War, Armstrong had invented a new, lighter, breech-loaded gun that fired a shell rather than a ball. The disused Tower 71 was to be the target and Armstrong himself travelled to Eastbourne to be the artilleryman. He tested 40-, 70- and 100-pounder guns from a range of 1,000 yards and it took only seven or eight rounds from each gun for the 6-foot walls of the tower to be breached. Within two hours a hole measuring 7 feet by 15 feet had been made in the tower and the many witnesses were given the opportunity to clamber over the ruins to inspect the damage.

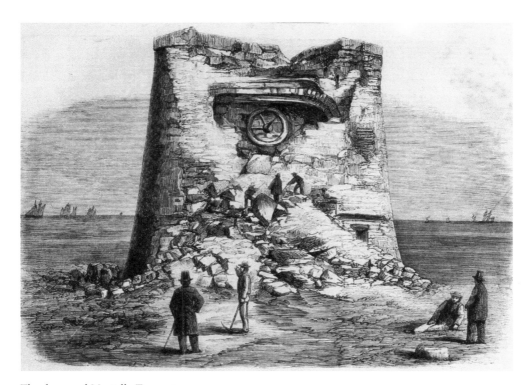

The damaged Martello Tower 71.

Princes Park

Mr Carew Gilbert-Davies gave 28 acres of his land to the council in order to create a new recreation ground. Unemployed men from the town topped the shingle with ballast and soil and lined the nearby Crumbles Pond. When the Prince of Wales unveiled a tree in the park in June 1931, the name was changed to Princes Park. I spent many a happy hour here watching the toy yachts skim across the shallow pond, or if I was lucky I would be allowed to take the helm of one of the brightly coloured pedalos.

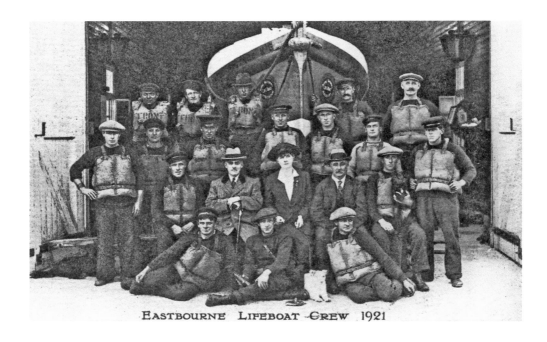

EASTBOURNE LIFEBOAT CREW 1921

Above: Eastbourne's lifeboat crew, 1921.

Left: My brother and I with the lifeboat *Beryl Tollemache.*

On the shore beyond the car parks and tennis courts is Eastbourne's fishing station. In 1903, the corrugated-iron lifeboat house was built to accommodate a new lifeboat called *The Olive*.

In the 1960s, two loud firework-like maroons would summon the lifeboatmen here to launch the lifeboat. Local men (including my father) would also attend, particularly at low tides when the lifeboat had to be dragged down the beach over huge wooden rollers to be launched.

There have been several 'splash points' in Eastbourne, but to me it was just to the east of the Redoubt where the sea defences (installed by the War Department in 1867 at a cost of £10,000) were a great place to play 'chicken' with the waves while the rest of my family sought the warmth of the nearby cafeteria.

The Redoubt Fort

In August 1803 the national press reported: 'The French mean to land between Beachy Head and Hastings and the company who usually frequent this place for sea-bathing have entirely deserted it.' It also reports that 'a temporary barracks to house 10,000 men is being erected on the beach. A night patrole [sic] has been established and additional signal huts have been erected'. Secret plans were written in case the French actually did land. Crops would be set on fire and 'houses of all descriptions' would be destroyed. Owners would be given a ticket to indemnify them of their losses.

The temporary barracks gave way to the Redoubt, the building of which started in 1804 but was not completed until six years later. It was a base for up to 200 soldiers and the whole of the area became a garrison town. Initially it was all men, but after the Napoleonic invasion was no longer a threat military families moved in.

The Redoubt Fort.

It is fascinating to get an insight into what it must have been like to work there. One soldier was George Smith, who was born in Scotland and enlisted into the Royal Regiment of Artillery at Glasgow in 1853. Two years later he was fighting in the Crimea, where he was left wounded on the field for so long that the British and Russian cannon shattered his eardrums, making him virtually deaf for the rest of his life. Returning from the war, he was posted to the Redoubt at Eastbourne in 1860 where he worked as a storeman. He soon met a local girl, Mary-Ann, who he married at Holy Trinity Church. They had twelve children, nine of which were actually born in the Redoubt. One of the children, Agnes, was interviewed in 1954 and recalled that their accommodation in the Redoubt was just one large room with a number of partitions to allow each family to have its own space. She said 'food was provided and eaten on a communal basis and cooked in the old-fashioned 'kitcheners''. The lighting came from old smoky paraffin lamps. There was also a communal laundry room and even a school for the children – all within the thick walls of the fort.

There were concerns about the Redoubt in 1888 when the War Office tried to auction it off and the reserve of £6,000 was not met. The *Eastbourne Gazette* was worried that if the surrounding sea walls were not maintained that we 'may wake up one morning to find the East End inundated'. The paper suggested that the building should be taken over by the council and turned into an aquarium or a place of public entertainment.

Eastbourne Council eventually purchased the building in 1925 and opened it to the public the following year, but what were they to do with it? Agnes was asked in 1954 and she believed that the building should become a military museum. 'Charge people sixpence to look around it,' she said 'and have me at the entrance to collect the money!'

On 7 June 1957, a model village opened in the Redoubt, promising 'the finest architectural models in the country, many of them based on gems of the Tudor period

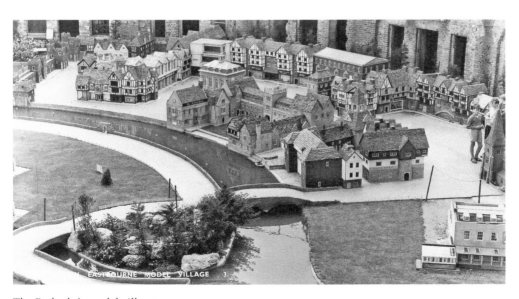

The Redoubt's model village.

which will be on display all year and illuminated at dusk'. (In the summer it was open until 10 p.m.)

Two years later the Blue Grotto Aquarium opened in some of the old military casements. The place was cold and damp with eerily blue-lit niches, which contained statues of Greek goddesses.

I remember these clearly and enjoyed walking around the narrow paths of the village but found the aquarium a bit creepy. The model village closed in 1975, but the aquarium managed to stay afloat for a few years afterwards.

Bathing Beauties

Adjacent to the Redoubt are the Pavilion Tea Rooms, often the venue of small but interesting historic exhibitions. These are free to the public and are always worth a visit. This area to the west of the Redoubt was the location of the 'Birdcage' Bandstand, which was relocated here from the seafront in 1922. It was such a popular venue that it was rebuilt in the early 1930s as the Redoubt Music Gardens with a large sun lounge area. Photos show the area crammed with visitors, not only to listen to the music, but to watch the shows put on by the *Daily Mirror* here.

In the summer of 1932 there were regular shows by ladies dressed in 'sapphire blue oil-skin bathing costumes'. They demonstrated 'Grecian ball dances, ballet and rhythmic exercises with dumb-bells'. It all seems rather glamorous, but their changing room was the back of a *Daily Mirror* van parked nearby. Today there are memorials here to Nelson Carter VC (see page 79) and members of the Royal Sussex Regiment who fought in Burma during the Second World War.

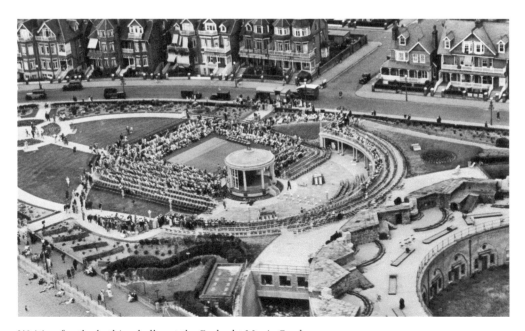

Waiting for the bathing belles at the Redoubt Music Gardens.

On the other side of Royal Parade is the Langham Hotel, which is graced by an original Victorian bathing machine in the summer. Invented in Scarborough in the late eighteenth century, these moveable changing huts allowed people to enter the water without clambering over the stony beach while retaining some modesty. In Eastbourne, they were pulled into the sea by horses, although at nearby Seaford – where the beach was steeper – they were lowered into the water by a winch.

The writer Tobius Smollet explained how to use them in 1771

The bather ascends into the wooden compartment by wooden steps and shuts himself in and begins to undress while the attendant yolks the horse to the end next-the-sea which draws the carriage forward til the surface of the water is at a level with the floor of the dressing room. The horse is moved to the other end and the person, being stripped, then opens the door and plunges headlong into the water.

Although they were a familiar sight on Eastbourne beaches, particularly between the pier and the Wish Tower, not many people realise that they were different inside depending on whether they were built for gentlemen or ladies. The ladies machine had more coat hooks and shelves, and sometimes a lockable box for jewellery. The gent's version was more sparsely decorated, but had a trapdoor in the floor so that an energetic young man could plunge directly into the sea rather than use the steps.

Bathing machines reached their heyday at the turn of the twentieth century, but were abandoned at the start of the First World War. Nearby Seaford Museum has a female version on display but the Langham one, lovingly restored by the previous owner, Julian Martyr, is a gent's version. Before restoration, both machines were in use as garden sheds.

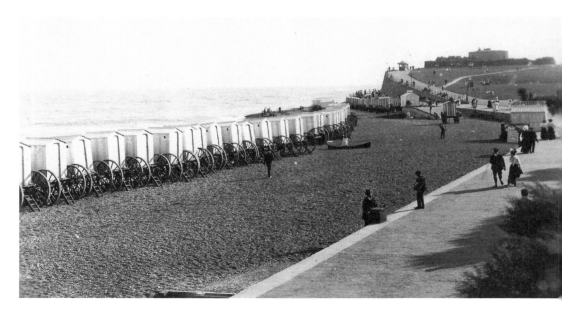

A row of Eastbourne bathing machines.

How the Secrets of an Ancestor Were Revealed

As we head towards the pier we can see two modern changing huts, erected in 2017. The white angular building here commemorates a special Eastbourne woman who lived nearby 2,000 years ago. I wonder if it is a coincidence that the building resembles a solitary tooth – for it was her teeth that revealed her secrets.

In 2011, Eastbourne Heritage Service received dozens of sets of Anglo-Saxon skeletons that had been discovered during excavations many years earlier. Modern archaeological techniques can determine amazing details which can give an insight into the lives of our ancestors. Led by Jo Seaman, Eastbourne Borough Council's Heritage Manager, osteoarchaeologists trained local volunteers to identify and conserve thousands of bones. The bones and teeth can reveal an awful lot of information as to the life (and death) of a person. Age, sex and ethnicity can be determined and telltale marks can show if a person was injured or had been suffering from disease.

From the 150 skeletons, the team selected eleven for further investigation. Their findings were astonishing. Firstly, they were not all from the Eastbourne area; one man was from the Chester area in north-west England, whereas another spent his formative years on the east coast.

The secrets of the skeleton labelled BH1959 were stunning. Sadly, the details of where it was excavated from have been lost; however, as it was likely to have been somewhere between Eastbourne and East Dean, she is known as 'Beachy Head Lady'. She was 5 feet tall and died when she was around twenty-four years old, sometime between AD 125 and 245 during the Roman occupation of Britain.

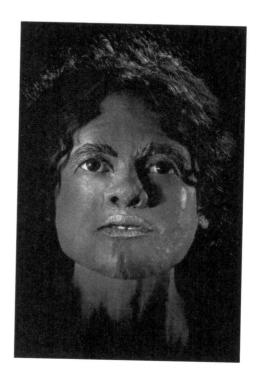

The enigmatic Beachy Head Woman. (Courtesy of Eastbourne Town Council)

The remarkable secret of BH1959 is that her bones reveal that her origins were not local, indeed they were from many thousands of miles away in Sub-Saharan Africa! Beachy Head Lady is the first identified black person known to be living in the British Isles.

Who was she and why was she in Eastbourne? It is easy to assume that she was some form of slave, but as she had a decent burial it is likely that she had a high status in the community. She may have been the wife or daughter of a high-ranking local official. Maybe he was black too, but his grave has been lost in time. There is other evidence of Roman Eastbourne too, which we shall see shortly as we walk closer to the pier.

Fountains of Help

Beyond the Glastonbury Hotel with its ornate cast-iron balconies, Marine Parade widens out into Marine Gardens. Beside the Fusciardi Ice-Cream Parlour is the 'Curling drinking fountain', which is worth crossing the road for (as is the ice cream!).

This elegant iron drinking fountain, surmounted by two entwined dolphins and a lamp, was originally installed opposite the nearby Leaf Working Men's Hall in Seaside in 1865. The fountain was made by the Handyside Company. Andrew Handyside of Derby was a famed Victorian ironfounder. The company made a variety of structures, from pillar boxes to huge bridges. They supplied bridges all over the world but also locally, including over 400 bridges for the London Brighton & South Coast Railway. The drinking fountain would have once had small troughs underneath for thirsty dogs, but these have since been blocked off. The fountain was originally donated by Mrs Elizabeth Curling (1790–1873), a local philanthropist. She helped to provide a chapel at the Eastbourne Workhouse and provided gifts for the inmates at Christmas. She assisted schoolchildren with generous donations to local school funds and prizes.

In 1859, she established and ran the Society for Promoting Female Industry. The purpose of which was to 'Supply poor industrious women with needlework during the winter months' and to 'help them to purchase cheap and useful items of clothing'.

When Mrs Curling died aged eighty-three in 1873, the *Eastbourne Gazette* said:

> The death of Mrs Curling will leave a blank not only in the public and private charities of the town, but in the hearts of all who had the privilege of her friendship. Distress, in whatever form it came before her, was sure to meet with sympathy coupled with a readiness to relieve it and the poor will feel that one of their best friends has been removed from them.

Waiter!

Heading towards the pier we have the Riviera Hotel, which was previously the Albermarle and before that the Anchor Hotel.

The Anchor Hotel (can you see the plasterwork anchor on the pediment at the top of the building?) was built in the early 1800s and had a 'posh' front facing the sea, but a rather more downmarket taproom and stables at the back. It was from here that horse-drawn coaches could be caught to London, Brighton and Hastings, and on at least one occasion the horses stabled here were commandeered to pull the Eastbourne lifeboat into the sea.

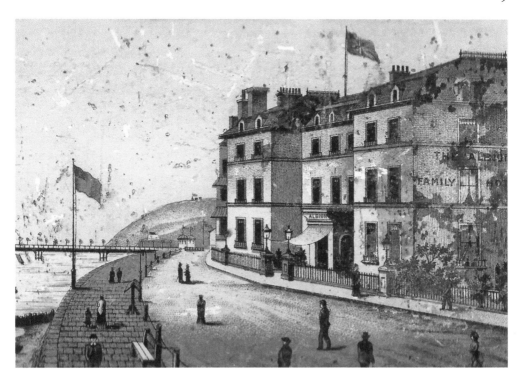

An early view of the Albion Hotel.

The next hotel is the Shore View – originally the Albion Hotel (which seems a perfectly good name to me). My first Eastbourne book was published in 1996 and I made the mistake of saying that the hotel was built for the Earl of Ashburnham. This led to a ticking off by the redoubtable Vera Hodsell, the knowledgeable secretary of the Eastbourne History Society. Over twenty years later I am happy to correct my mistake; the Albion was built in 1821 as the Boy's Hotel (named after Edward Boys) and the earl did not take residence until 1850s. Unfortunately, when the earl was in residence the painted 'HOTEL' sign was still visible. On one occasion, a traveller entered the lobby and called out 'Waiter!' There being no reply, he called even louder until the indignant earl appeared wondering what the noise was about. The visitor responded by saying to the earl, 'Bring me a glass of Sherry!' It is not surprising that the he sold the house soon after.

DID YOU KNOW?
The Earl of Ashburnham was once riding in Eastbourne with the local vicar when they passed a group of workmen. The earl turned and asked the vicar if poor people were allowed into Heaven. Apparently, he was most indignant to find that they were!

When the telephone came to Eastbourne, the Albion Hotel acquired the number 'Eastbourne 1'.

Further along, Nos 6 and 7 Marine Parade are early eighteenth-century listed buildings. In 1860 one of the residents was Charles Darwin.

The splendid Queen's Hotel was built by Henry Currey (1820–1900) the architect to the Duke of Devonshire. It was possibly built as a visual barrier between the 'posh' hotels of Grand Parade and the cheaper establishments to the east. Indeed, until 1898 there was no continuous road here, just steps at Splash Point down onto Marine Parade.

There were gushing reviews of the hotel when it opened to the public on 1 June 1880. There were sixty bedrooms over five floors but only two bathrooms, and there were no toilets in the main hotel as they were provided in a separate wing.

The modern furniture, a revival of the Old English style, was provided by Maples of Tottenham Court Road, London – made with walnut on the first and second floors, pine on the third floor and oak on the top two floors. All rooms were provided with tapestry curtains and carpets from Brussels. There was a basement restaurant that, for some reason, had separate dining rooms depending on whether you were eating hot or cold food, a large drawing room with a piano, a library, a ladies-only room and a smoking room. A hydraulic lift could take you to the top of the hotel where there was a viewing tower.

The German-born manager John Steinle became an English citizen and managed the hotel until 1900 when the famous musician Sir Arthur Sullivan was a guest. Steinle went on to manage the Chatsworth Hotel. He died during the First World War in 1917 when all Germans were viewed with suspicion, so it is not surprising that although his obituaries

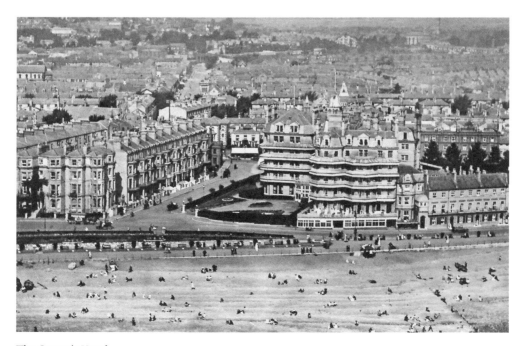

The Queen's Hotel.

mention he was a freemason, president of the Eastbourne YMCA and the director of the Artizan's Dwellings Company, they fail to mention he was a German.

In 1915, Ludwig Selbach, a suspected German spy, was arrested in London. Westminster Court heard how he had lived at the Queen's Hotel in Eastbourne for two months with a Mrs Hamilton (apparently a lady of 'sinister repute'). During the First World War, Eastbourne was a 'prohibited area' and the couple had pretended to be Americans. Selbach was not convicted of spying but sentenced to six months' imprisonment with hard labour for failing to register himself as an 'alien'.

Field House and Round House

The seafront at the Queen's Hotel was called Splash Point and the area that is now the hotel car park was the site of Field House, a ten-roomed building owned by Major Leonard K. Willard of The Greys in Old Town, and let to summer visitors. In fact, Willard owned most of the land in this area.

Major Willard was a redoubtable character who had lost an arm at the Battle of Laswari in North West India while a captain in the 11th Battalion of the Royal Veterans (a part of the British East India Company). The battle saw many casualties so I was amused to read that the major's middle name was 'Kilham'.

In the picture overleaf, Field House is on the right. The building on the left is the Round House, which stood roughly where the entrance to the pier is today. By the mid-1800s both houses were precariously close to the shoreline.

The Round House must have been a fascinating building to have visited as it was constructed in 1757 as a horizontal windmill. There are only five horizontal windmills known in the whole country and three of them were in Eastbourne. They were built by

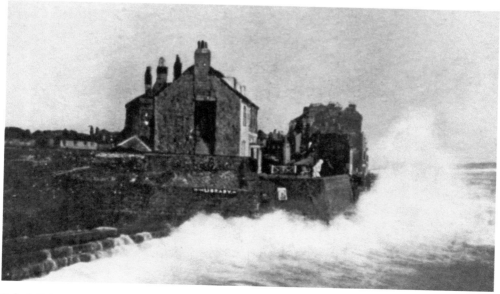

Splash Point.

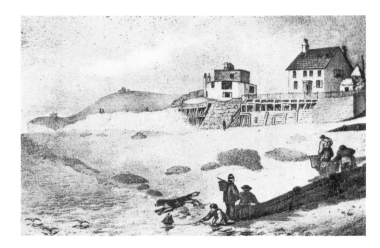

The Round House (centre) and Field House (right).

Thomas Mortimer and were used to grind corn. Sadly, there are no illustrations as to what the mill would have looked like. However, writing in 1881, Robert Cooper said:

> The large building stands in a field enclosed by white-painted palings, waist high and was about twenty or thirty feet off the edge of the cliff. A model of the building could easily be made by placing a dice on top of a pill box. Older people remember seeing cattle feeding in a meadow directly under where this house now stands.

It is difficult to think that this busy area of seaside Eastbourne was once so rural.

The box on the top of the mill would have contained louvres or vanes and it is probable that the central shaft would have been directly attached to the millstones below, although there were 'valves' to regulate the power. There was another horizontal mill on the Downs above Victoria Drive (Pashley Down), but this burnt down on 3 May 1811. By this time the Round House on the seafront was being used as a guest house, indeed in 1780 it was visited by the children of George III.

A Secret Unearthed

Although the long-lost houses here are of interest, the surrounding land holds a secret that few Eastbournians know about. This was the site of Eastbourne's Roman villa.

In 1712 workmen were repairing a fence but found difficulty sinking holes for the fence posts because of an obstruction. A subsequent excavation revealed the remains of a Roman bath (17 feet by 11 feet) and beautifully decorated pavements. Although this was a revelation to the gentry, the local people had already noticed the extensive foundations because of the lack of growth in the corn and grass in dry summers and the occasional tesserae (parts of a mosaic) that came to the surface during ploughing.

Sadly, the remains were not preserved. The ruins were visited by the Reverend Jeramiah Miles who is noted for writing about his two 'grand-tours' to Europe. He became the Dean of Exeter Cathedral and the president of the Society of Antiquaries, however in August 1743 he was here at 'South-Bourn'. He wrote:

The publick houses are situated on the sea shore, where they frequently catch good fish... not far from our Inn was discovered a mosaick pavement and bath. Both are now entirely destroyed so that one can now only see the bed of plaster in which the mosaick was fixed. Everybody that came to see it took away pieces of it, and no care was taken to preserve it. From here, all the way to East Bourne, which is about a mile further, they find foundations of Roman Walls

When the Round House was demolished in 1841, further Roman remains were discovered. This time the site was visited by Mark Antony Lower, who was the Sussex historian that established the Sussex Archaeological Society five years later. Lower made a record of the extent of the villa which seemed to have been substantial and included several large rooms as well as a long decorated pavement and of course the bath. He also mentions *'pottery with figures of animals and the names of the potters stamped on the vessels'* and gold coins of the Emperor Gordian (238–244 AD) which helps to date the villa.

The grandeur of the villa was evidenced in 1853, when the foundations of Nos 3 and 4 Grand Parade were being dug and the bases of two large Roman columns were unearthed. It would be wonderful to see this evidence of ancient Rome in Eastbourne but sadly these monumental relics were smashed up and included in the foundations.

And what of the rest of the historic 'finds'? They seem to have been distributed to local people, many of them were taken to 'The Greys' the family home of the Willard landowners (*see* page 77). Several items were on display at Eastbourne Museum but these were destroyed by enemy action when the 'Technical Institute' that housed the museum received a direct hit on 4th June 1943.

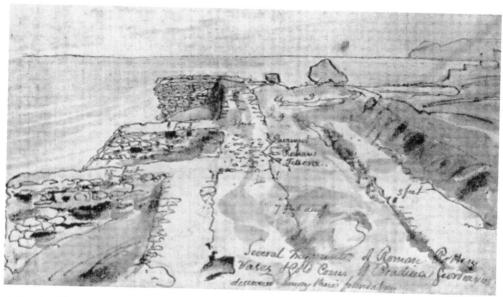

A sketch of the Eastbourne Roman villa.

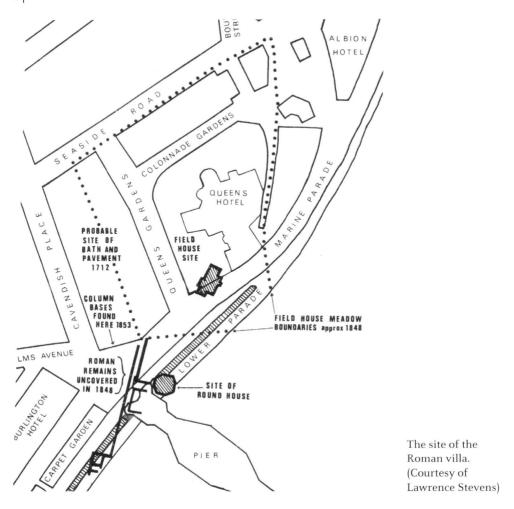

The site of the
Roman villa.
(Courtesy of
Lawrence Stevens)

The Ups and Downs of the Pier

We now move on from a secret Roman villa to the pride of Eastbourne: the not-so-secret pier.

Much has been written about the pier. It was designed by the famous pier designer Eugenious Birch and the first pile was screwed into the seabed on 18 April 1866. At 5 p.m. around 3,000 people witnessed Lord Edward Cavendish deposit documents in a tin box that was sealed into the iron column. The *Eastbourne Gazette* (which had been using a picture of the proposed pier as its banner head since the beginning of the year) spoke of how the 1,000-foot-long pier would benefit the town. It enthusiastically reported that the view from the end would stretch from the cliffs of Hastings to the 'bold and magnificent Beachy Head', which was not visible from the Esplanade. In fact, the marine panorama would be 'unsurpassed in beauty from any other watering-place in the kingdom!' The chairman of the Eastbourne Board optimistically declared that the pier would be open to the public by the summer of the following year, before setting off to the nearby Anchor Hotel with the 'chief residents of the town' for a slap-up meal. It was not open the next

summer. In fact, although it was opened to the public on 13 June 1870, the pier wasn't completely finished until 25 November 1871.

DID YOU KNOW?

It is fascinating to see what was on offer for the meal: mock turtle, clear oxtail and asparagus soup. Souchee (boiled) flounders, soles and eels. Salmon with cucumber, turbot, lobsters, cod, fried soles, whiting and smelts. Sweetbreads, stewed kidneys, curried rabbit, rissoles, stewed veal, stewed pigeons and cutlets. Lamb, haunch mutton, boiled and roasted fowls and tongues. Ptarmigan, hares, and white grouse. All of course served with an array of vegetables. For sweet there was jelly, blancmange, gooseberry tarts, cabinet puddings, custard, macaroni cheese (!) Neapolitan gateaux, cream and ice cream followed by stilton and cheddar cheese. What a feast!

The pier lasted just over five years, as on 1 January 1877 the whole of the landward end was washed away during a storm. When it was rebuilt, the new section was slightly higher than the original pier, which is why there is a ramp around halfway along. Another gap was knocked through the pier during the Second World War and a Bofors anti-aircraft gun was installed.

The original pier was rather sparse but over the years buildings were added. The first theatre was built in 1888 at a cost of £250. It could seat 400 people but in 1899 it was replaced with a much larger structure, which included café's, a bar and pier offices. The crowning glory for me, however, was the camera obscura, secreted away in the dome at the very top. I clearly remember climbing the white and blue steps and entering a small round room dominated by a saucer-shaped table. Visitors would gather around this table and the door was closed and windows covered, plunging the room into darkness. The attendant would then pull a rope that opened a small hole above and a mirror would

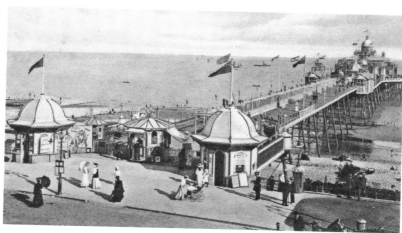

Eastbourne Pier.

Left: Anti-aircraft gun on the pier.

Below: The camera obscura under the golden dome.

direct a clear coloured image of the Esplanade onto the table. You could see the cars and buses moving, and even people. I am told that it was one the largest in the country. It impressed me back in the 1960s, but I imagine that it would have been even more magical to a Victorian.

The theatre was burnt down on 8 January 1970 by a disgruntled employee. I witnessed the fire and recall visiting the burnt-out theatre with the rows of blackened seats. Nearly fifty years later I can still recall the acrid smell.

A Memorial to the Lost and a Lost Memorial

Opposite the pier is the Royal Sussex Regiment statue, which is now an inconvenient traffic island. You have to take your life into your hands if you want to get close enough to view the plaques. The statue is of a smart, upright soldier dressed in the uniform of a member of the Bengal Regiment, holding a sword in his hand. To save you being run over, the main plaque reads:

ROYAL SUSSEX REGIMENT
To the honour and glory of the officers, non-commissioned officers and men of the 2nd Battalion, Royal Sussex Regiment, formerly 107 Regiment, Bengal Infantry who lost their lives during the service of the battalion abroad in Malta, Egypt and India from 1882

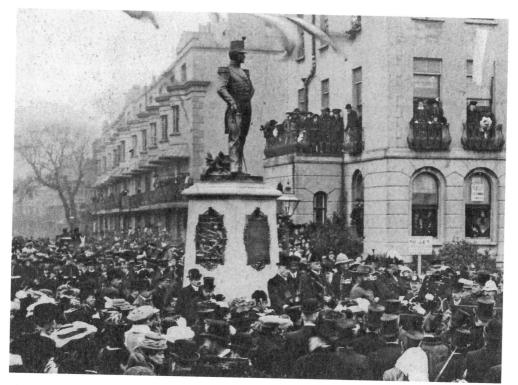

The unveiling of the Royal Sussex Regiment statue.

to 1902 and in special memory of the campaigns in which the battalion took part. The Black Mountain Expedition of 1888 and the Tirah Campaign of 1897–98. This Memorial has been erected by their comrades.

The statue was unveiled in front of a huge crowd on 7 February 1906. I have a postcard in my collection showing the unveiling. Amazingly, it is postmarked the very next day.

Although the statue lists many men who were killed during the days of the empire, many more local men of the Royal Sussex Regiment were to be killed during the First World War just a few years later. The sculptor was a Welshman called William John. He used the name 'Goscombe-John', Goscombe being a village where he had once lived. He was to later make his name and fortune by providing First World War memorials across the country.

In 2017, I visited the grave of Goscombe-John in Hampstead Cemetery in London. I had been told that it was noted for the memorial statue that he himself had designed. Sadly, although I found the grave, I was disappointed that the statue had been stolen a few years earlier.

Mystery Tours

The forecourt of the pier (shown here in 1905) was always busy with taxis, bath chairs, carriages and charabancs all plying for hire. My great-great-uncle William Vinall lived in Arlington and made his own charabanc in his garage. When it was finished it was too large to leave, so the whole side of the building had to be demolished to drive it out! He plied for hire from Eastbourne Pier, where he would take holidaymakers on 'Mystery Tours'. Many other mystery tours ended up at Wannock Tea Gardens or Pevensey Castle, but not William's charabanc. His secret location was more often than not his own house, Woodlands, opposite Abbots Wood. His wife, Alice, would be waiting with pots of tea and jam sandwiches.

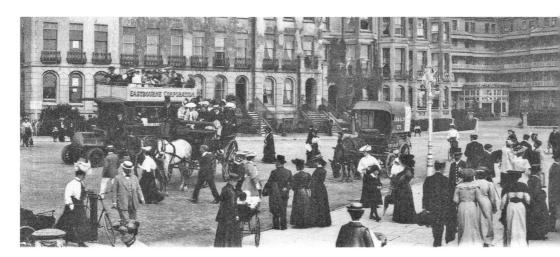

Traffic at the pier.

The photograph shows an Eastbourne charabanc outside the Tivoli Cinema in Seaside in 1923. My great-uncle Reginald Gordon was a projectionist at the cinema for many years and both he and my grandfather are sitting in the vehicle. I wonder where they were off to. Wherever it was, it was going to be a bumpy ride – look at those solid wheels!

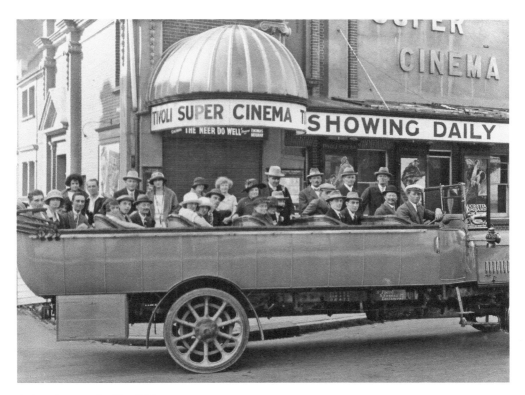

A charabanc at the Tivoli Cinema, 1905.

DID YOU KNOW?
Ecmod Road is uniquely named. It stands on the site of the former bus works and is an acronym of 'Eastbourne Corporation Motor Omnibus Depot'.

2. The Pier to Holywell

Another Dark Secret

Opposite the famous Carpet Gardens (now sadly missing their ornamental fountains), is the huge expanse of the Burlington Hotel. The building was originally a series of nineteen terraced houses built between 1851 and 1855. It was in one of the terraced houses to the left of the building that a nasty crime took place in 1860.

Teacher Thomas Hopley had a school at No. 22 Grand Parade, on the corner of Victoria Place (now Terminus Road). Forty-one-year-old Hopley was a religious man and claimed to be a great philanthropist. He published pamphlets on 'respiration and exercise' and also spoke out about the 'sufferings of overwork by women and children in factories'. His concern for children, however, did not extend to his own pupils, to whom he was a brutal authoritarian; he had a reputation for beating his pupils so much that his punishments could be heard by those passing his school.

One of his pupils was fourteen-year-old Reginald Cancellor, the son of a lawyer who served as the 'Master of Common Pleas' in London. Reginald must have been a difficult

16. THE BURLINGTON HOTEL, EASTBOURNE.

Hopley's school was in the building on the left of the Burlington Hotel.

boy to teach. He is described as being a 'backwards lad with a large head, fat, greedy and with poor table manners. He bit his nails and had sores on his face'. Today the child would be identified as having special needs and would go to an appropriate school, but Hopley's only method seemed to be beating the boy into better work.

Reginald's father complained to Hopley when he found that his son was covered in bruises during the Christmas holiday of 1859, but Hopley assured him that the beatings were not excessive and in the best interests of the boy. In April 1860, Hopley wrote to the boy's father seeking permission to inflict harsher punishments on Reginald. He said that the boy's temper had to be subdued, even if it meant carrying on beatings for up to two hours. Mr Cancellor reluctantly agreed and, on Saturday 21 April 1860, Hopley beat the boy to death with a cane and a skipping rope.

He laid out Reginald's body and threatened the frightened housemaids, who had been disturbed by the noise, telling them to say nothing. He did not call a doctor until the following day, suggesting that the boy had died while having a fit. The doctor issued a death certificate, giving the cause of death as 'heart disease' and the inquest, heard three days later, returned a verdict of 'death by natural causes'. It seemed Hopley had got away with murder.

Reginald's father, however, was not so easily fooled. On travelling down to Eastbourne to retrieve the body, he asked some pertinent questions of Hopley and the maids and was not satisfied with their demeanour or their answers. He insisted that a post-mortem be held and the true extent of the boy's suffering was revealed, as well as a more probable cause of death.

The maids are woken by the beating.

She Heard Sounds as of Someone Being Beaten.

Family lawyers travelled to Eastbourne to obtain an arrest warrant and Hopley was arrested at Polegate station. The arresting officer was the chief constable of East Sussex, Lieutenant Colonel Henry Fowler Mackay. He was a personal friend of the prisoner and indeed his two children had been educated by him.

It is clear that the case divided opinion in the town. Some people described Hopley as kind-hearted man of considerable ability; however, others believed that he not only abused his pupils but his wife as well. When she gave birth to a boy in June 1856, Hopley was unhappy with the speed of her recovery. A few days after the baby was born, he invited his wife to go for a ride in the countryside, no doubt to get some fresh air. Half an hour later, when they were several miles away from Eastbourne, he stopped the carriage and pushed her out, telling her that she would have to walk home.

On 2 May 1860 Hopley was bought before the magistrates at the Vestry Room in Grove Road, who heard enough evidence for him to be committed for trial at Lewes Assizes. He pleaded his innocence (his trump card being the letter from the victim's father), but admitted that he had beaten the boy at periods throughout the day and had refused to feed the boy as he was stubborn. However, he said that the boy 'had gone comfortably to bed'. This was disputed by the two maids who said they had heard him beating the boy into the early hours and a coastguardsman who said he had seen Hopley moving about the building in the small hours.

Hopley was found guilty of manslaughter and sentenced to just four years' imprisonment, which he served on the Isle of Portland. On 5 November that year Hopley was burnt in effigy by the local Bonfire Society.

After his sentence, Hopley returned to Eastbourne but was a broken man. His wife managed to get a divorce from him and left the country. He even tried to re-establish his school, begging the local magistrate, Reginald Graham (the very same magistrate who had dealt with the case), to allow him to educate his children. Not surprisingly, Graham declined.

DID YOU KNOW?

Local magistrate Reginald Graham recalled how in the 1860s many married couples believed that they could obtain a divorce if they could get the bells of St Mary's Church to be rung backwards!

Seaside Entertainments

The Esplanade between the pier and the Wish Tower was the busiest part of the seafront, with a variety of noisy distractions for the visitor. There were fortune tellers, hawkers, minstrels (often in blackface), flower sellers, organ grinders, fish sellers, toy merchants and marching bands. Jaunty sailors would be calling out for visitors to join them for a boat trip around the bay and, as well as people imploring you to use the bathing machines, there were also ladies offering swimming lessons for children.

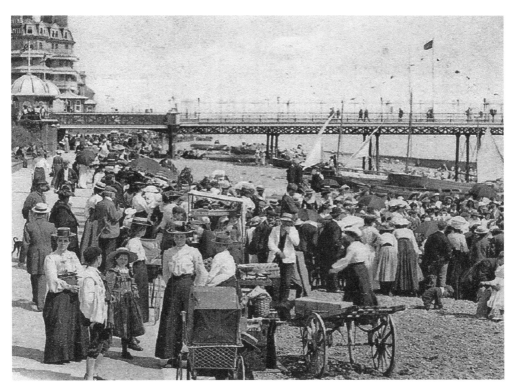

Seaside entertainment.

Ted Hide, in his excellent book *The Pleasure-boatmen of Eastbourne,* quotes a visitor in 1871. He gave a vivid account of the noises and smells:

> There are two town bands and two rival town-criers, each having a long list of announcements, chiefly relating to articles lost by ladies on the beach, each announcement introduced by a loud clanging on a large bell. There are the cries of the fish sellers 'FRESH BILED [boiled] PRAWNS' and 'FINE LIVE HYSTERS' [oysters]. These are the size of saucers and need a strong man to open them and an even stronger man to digest them! The choicest noises, the obtrusive hawkers and the most insolent beggars, the jugglers and buffoons reserve their favours for the beach at the Grand Parade.

Although I am sure that the local council board wanted Eastbourne to be seen as a quiet genteel resort, it seems that it was far from it. The magazine *Ally Sloper's Half Holiday* was first published in 1884. The eponymous Ally was a big-nosed boozy schemer who regularly tried to 'slope off' paying his debts. The title referred to the new Sunday half-day holiday that working classes were given. (The word 'weekend' did not appear in the Oxford English Dictionary until 1879.) The magazine was cheap and aimed at working-class people, once boasting that it had the largest circulation in the world. In the 1880s the magazine ran a column 'Tootsie in Eastbourne'. Tootsie was Ally's pretty

daughter, who travelled to the coast in the summer with her friends. Her observations about the town are interesting; she seemed to enjoy the hustle and bustle of the seafront but complained about the 'well-to-do' people who would drive up and down the prom and block up the pier and Devonshire Park on a Sunday.

As I mentioned in my introduction, I am lucky that I still have many photographs taken by my grandmother back in the 1920s. One of these photos caught my eye. It shows a crowd gathered to the west of the pier looking at what appears to be a man in a barrel. My grandmother was obviously in a boat when she took the photo, which is why the image is not too clear.

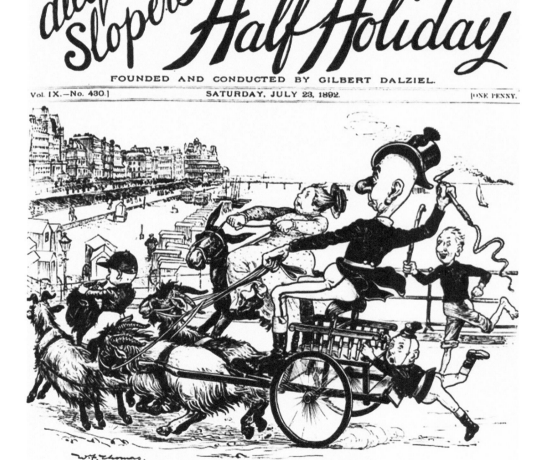

Ally Sloper's popular magazine.

Biddy and his tub.

I have discovered the name of the man in the barrel: he is Biddy Stoneham. Alfred Mills Stoneham (known as Biddy) was born in 1879 and was a Hastings fisherman who had served in the Navy during the First World War. He would travel along the Sussex coast in the summer with his tub – a barrel with the top cut off – and perform a number of tricks, jumping in and out of the tub or running around the rim. One of his favourite tricks was to select a young lady 'bathing belle' to sit in the tub as he gently pushed her through the water. He would then tip her out and then gallantly 'save' her. For his efforts, Biddy would collect money for lifeboat charities. Indeed, he once received a bravery medal from the Lifeboat Institution. Biddy was an attraction at several Eastbourne regattas and during the Second World War helped to evacuate soldiers from Dunkirk. He died in 1964.

A Bawdy Flower Seller

If you were to have walked along the prom towards the pier during the late Victorian period, you certainly would have seen and heard Kitty Quill. Her pitch was on the seafront opposite the Sussex Club, near the Carpet Gardens.

Elizabeth Quill (known as Kitty), was born in Ireland in 1861. At some stage, she moved to London where she met labourer David Quill. Although they lived in London, Kitty spent the summer in Eastbourne where she lodged and did a brisk business as a flower seller.

As we will see later, the Dukes of Devonshire regularly hosted members of the royal family at their seaside home at Compton Place. In 1878, Queen Victoria's daughter was staying there for six weeks. As her flowers were supplied by Kitty, she became known locally as 'Fair Kitty – The Royal Flower Girl'.

Kitty Quill.

Unfortunately, her pitch happened to be near that of the Eastbourne town crier, Henry Wood. The two didn't get on; indeed, the local press reported that previously the town crier had beaten Kitty's husband in a 'pugilistic box'.

One warm September morning Kitty was sitting on the promenade chatting with another flower seller, Annie Lee, who is described as a 'red-cheeked good-humoured lass'. Wood's main occupation was managing a lending library and he complained to Lee that one of her books was overdue. Kitty didn't like the tone of the man and began to shout at him. When Wood told Kitty to stay out of the matter, she threw a flower box at him. You can imagine the flower seller and the town crier yelling at each other with their considerable voices – hers with an Irish brogue and his with his stentorian tones. Words came to blows, which resulted in 'Fair Kitty' holding her apron to her face to staunch a flow of blood. But, was poor Kitty beaten? Of course not! She knocked the town crier's bell from his hand and proceeded to drag him along the prom back towards her house so her husband could 'wreak dire vengeance for so unpardonable an outrage'. The poor captive man could only beg for mercy.

Although it seemed that Kitty rather started this unsavoury row, it was the town crier who appeared at the magistrates' court and was duly fined 20s for the assault.

In November 1890, Kitty was once again before Eastbourne Magistrates' Court, but this time as a defendant accused of using obscene language. The complainant, Mrs Catherine Webb, accused Kitty of using the 'most filthy language'. Kitty replied 'Ditto', and the court

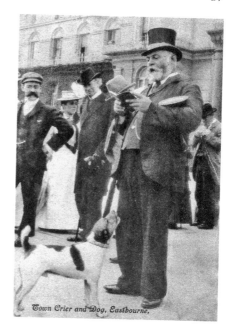

The town crier.

laughed. There was more amusement when Kitty said she only used bad language when she was quarrelling with someone else. She was fined 10s.

Kitty and her husband had a volatile relationship and in July 1891 she sought legal protection from Eastbourne Magistrates. She accused her husband of threatening to assault her. David (described as a militiaman) appeared in court with a black eye and in his defence he stated that he was the victim.

The summer of 1899 was unusually hot. The Duke of Devonshire's royal guests that year were the Prince and Princess of Wales. As the prince and the duke rode along the seafront, Kitty threw a buttonhole for the heir to the throne. He caught it but dropped it. The duke and the prince were attending an agricultural show and Kitty decided to go along too, paying the half a crown entrance. She approached the prince and duke as they were looking at some sheep and gave him a bunch of carnations. The future king thanked her and said she was a 'very good woman', which made her very proud. She then turned to the duke and said, 'Your Grace, I have had the pleasure of giving your wife some flowers before.' He remembered her and shook her hand. A gentleman then took Kitty aside to a nearby marquee and gave her a glass of champagne, saying: 'Kitty, you deserve a drink for your pluck and endurance!'

Later that same year, on 11 September, Kitty was arrested near Hailsham for assault and using bad language. Despite her plea of innocence, she was fined £1, but when the magistrate agreed to allow her time to pay she burst into tears and 'poured a volley of abuse upon the constable'.

Kitty was a regular feature of Eastbourne for decades and several postcards show her with a basket of flowers to which is attached a 'By Appointment' sign. She was a proud woman, but obviously not a lady to be crossed! She died in Eastbourne in 1929.

Policing the Front

The Eastbourne Borough Police (established in 1891) tried to keep law and order and appointed a parade inspector to patrol the beach. In 1926, the force recruited a policewoman whose duties included patrolling the seafront to deal with lost children, checking itinerant clairvoyants and ensuring that the many postcards for sale were not too risqué.

Although not much could be done about noise, in 1911 a bye-law was passed forbidding dogs to bark on the beach! This caused considerable amusement. I have a postcard dated 1911 (would you believe, sent to an address in Barking!) showing three white-helmeted Eastbourne policemen and the mayor keeping an eye on a suspicious-looking dog. The sender of the card has written on the back: 'Those awful dogs how dare they bark!' Another postcard published at the time gives advice to visitors:

> Dogs are not permitted to bark on the beach. It is said barking prevents the motor buses being heard, and, as these belong to the Corporation they are of course noiseless! ...

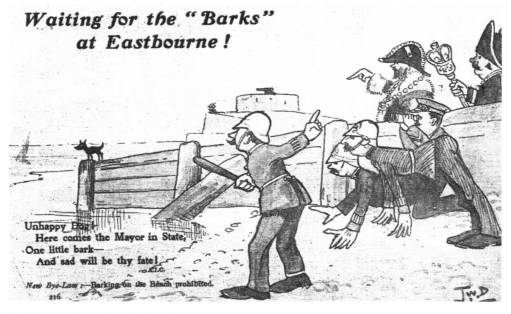

Barking was banned on the beach.

When in the vicinity of the town hall raise your hat slightly and walk on tip-toe. This is important ... Be very particular as to what you wear, a ragged costume may entail fearful penalties. The Police are vigilant and possess wonderful eyesight.

This last comment probably refers to a local character who would regularly be seen walking along the prom. Her name was Clara Wilkinson. When she appeared in court in 1905 her clothes were described as 'a hood-like bonnet of some brown material; a jacket discoloured by age and weather with a black fur collar sewn on with string and skirts consisting of rags extending scarcely to her ankles, there were holes in her stockings and her boots were battered. She also carried a baggy and dilapidated umbrella.' She was fined £3 by magistrates in 1906 for indecent behaviour and 'refusing to go home' (she lived in Brightland Road). She was summonsed in 1911 for being 'insufficiently dressed'. The magistrates heard on many occasions that she had sufficient money to buy better clothes but refused to do so. On one occasion the exasperated magistrate Major Molineux said to her: 'The wisest thing you can possibly do is to dress in the same manner as other people! You must know, as well as everyone in the town knows, that the manner in which you are dressed is nothing less than an outrage on society! It is a complete scandal! You must dress like a sane person and this state of things cannot be allowed to continue.'

This eccentric lady became such a regular sight on the seafront that postcards were sold of her.

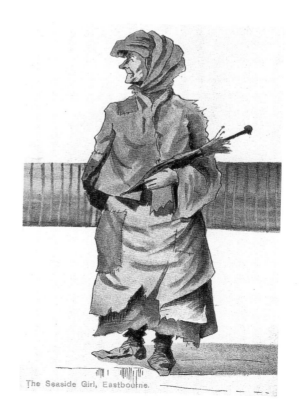

Clara Wilkinson.

The Seaside Girl, Eastbourne.

Bandstands and a Disaster at Sea

The first bandstand was built between 1883 and 1884 and was also nicknamed the 'birdcage'. This was replaced by the modern bandstand that graces the seafront today. It took nine months to build at a cost of £34,000. The bandstand was opened by the Right Honourable Lord Leconfield on 5 August 1935. Lord Leconfield (Charles Wyndham) lived at Petworth House and served as Lord Lieutenant of Sussex from 1917 to 1949. The first concert was taken by the band of the 2nd Battalion of the Seaforth Highlanders. The bandstand, designed to entertain up to 3,000 people, was an immediate success although not everyone was happy and there were letters to the local paper saying that the new structure should have been built at the other side of the Wish Tower, which attracted 'a better class of visitor and residents'.

Many people today walk past the bandstand without realising that it has a hidden secret. There is a memorial on the back wall of the bandstand to a victim of the *Titanic* disaster in 1912. John Wesley Woodward was an experienced musician. He was a member of the Eastbourne Municipal Orchestra, the Grand Hotel Orchestra and the Duke of Devonshire's Orchestra based at the Devonshire Gardens. From Eastbourne, he went to Jamaica and then played on a number of liners including the RMS *Olympic*, the sister ship to the fateful *Titanic*, which he joined for its maiden voyage. He made it known that this was to be his last trip and he intended to return to Eastbourne to settle down. Sadly it was not to be: John was one of the 'hero musicians' who kept playing as the *Titanic* sank under the icy waters of the Atlantic.

The *Titanic* Memorial was unveiled on 24 October 1914 by the Sussex-born singer Dame Clara Butt and was restored for the centenary of the disaster in 2012. If the bandstand is closed, the friendly and helpful Eastbourne Council staff in the nearby Seaside Office may be able to allow you to see it.

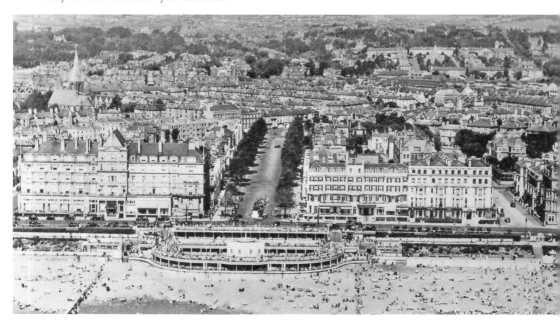

Eastbourne's bandstand from the air, showing the wide Devonshire Place.

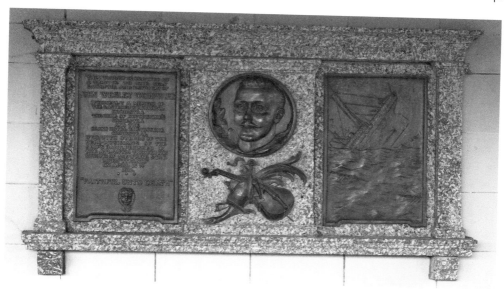

Above: Eastbourne's *Titanic* Memorial.

Right: The 7th Duke of Devonshire.

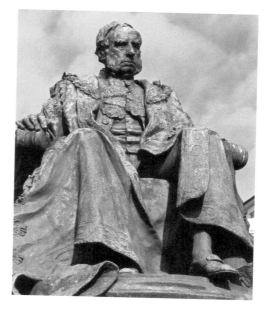

Opposite the bandstand, William Cavendish, the 7th Duke of Devonshire, sits wearily on a seat at the seaward end of Devonshire Place. This 80-foot-wide tree-lined road was due to be part of a wide route to direct visitors from the railway station straight to the seafront, but sadly today it is just a car park. The duke saw much of the development of Eastbourne in the nineteenth century. He was a Member of Parliament from 1829 to 1834 when he became the Earl of Burlington and took his seat in the House of Lords. Cavendish was the Lord-Lieutenant of both Derbyshire and Lancashire. His statue shows him wearing the robes of the Chancellor of Cambridge University. The statue was by

Goscombe-John, who was the sculptor for the Royal Sussex Regiment statue we saw earlier. It was unveiled on 17 August 1901.

To the duke's right is the Cavendish Hotel, which was built in 1865. The hotel was bombed on 4 May 1942, which is why the corner block looks more modern than the rest of the building. By the way, I am told that the flagstaff nearby is a massive 16 metres tall.

The Murder of Breezy Bill

The murder of William Terriss was not in Eastbourne but in London. Terriss was an immensely popular Victorian actor but he was stabbed to death at the stage door of the Adelphi Theatre on 16 December 1897 by a disgruntled rival. The *Daily Telegraph* raised funds for a suitable memorial and worked with the RNLI to provide a new lifeboat house near the Wish Tower as a fitting memorial to Terriss, who had been a merchant sailor before treading the boards. He had travelled around the world and on one occasion was shipwrecked. His nickname had been the rather nautical 'Breezy Bill'.

The foundation stone for the lifeboat house was laid in front of a large crowd by the Duchess of Devonshire on 16 July 1898. The marble memorial plaque on the side of the building is topped by a ring of golden ivy leaves – the symbol of remembrance.

The lifeboat was then *James Stevens No. 6*, but when it was withdrawn from service in 1924 the boat stayed in situ and was used for demonstrations. These events became so popular with residents and visitors that the Lifeboat Institution decided to turn the building into Britain's very first lifeboat museum. It was opened as a museum on 22 March 1937 by the chairman of the RNLI and Ellaline Terriss, the actor's daughter. It remains a fascinating place to visit and is full of maritime history. The volunteers are always happy to help and there is even a small shop.

William Terriss.

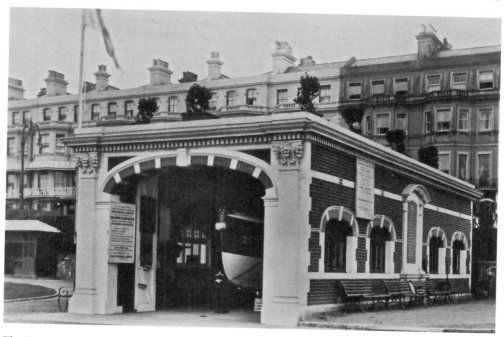

The Terriss Lifeboat House.

The rarely noticed lifeboat rescue.

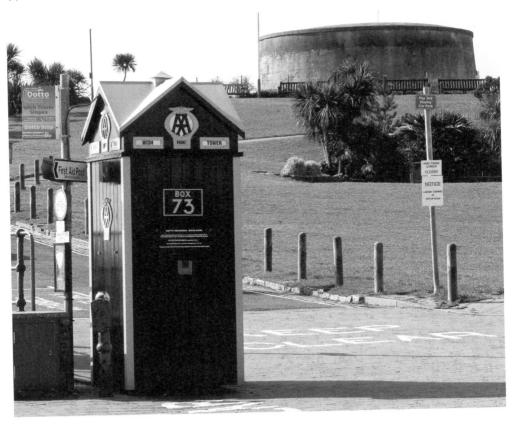

The restored AA box.

If you look above the main doors of the building you will see two triangular terracotta panels showing early lifeboats rescuing stricken ships. Sadly, these rarely noticed features have weathered badly. In a better state is the restored AA box sited nearby as a base for Rolls-Royce tours of the seafront. Every member of the Automobile Association had a key to give them access to these distinct black and yellow phone boxes from where they could arrange for a motorcycle patrolman to attend. The boxes first appeared in 1912 and were often the bases for the patrolmen themselves. That same year the AA also started to grade local hotels and guest houses for their travel guides. The box that currently stands here was put in place in 2015.

The Wish Tower

The Wish Tower is perhaps the best placed of all of the Martello towers. Built on a small hillock, it commands an excellent view of the coast between Beachy Head and the Redoubt. It is built on just over 2 acres of land close to a low marshy area (now Devonshire Park) that was once called The Wash or Wish; indeed, it is probable that this area was once a small harbour. The ground was built up around the base of the tower to form a dry moat. A plan in the National Archives shows the boundary stones that marked the extent of the

War Department land and also how the sea had eroded the nearby cliffs before the sea defences were put in place.

I am a trustee of Seaford Museum in Tower 74, so I was very keen to have a peek inside the Wish Tower – Tower 73 a couple of years ago. Our tower is full of an eclectic display of items (the Turner Prize-winning potter Grayson Perry once called it one of the greatest museums in the world!), however because of this it is sometimes difficult to imagine what the building was like when it was in use as a fort. This is not the case with the Wish Tower, although it was previously used as a museum and even a puppet theatre, you can still get a feel of its military past.

The interior remains a secret for many but the Friends of the Wish Tower do arrange occasional tours, which are fascinating. Donning a hard hat and entering the building, it takes a while for your eyes to get accustomed to the light, which comes from a high barred window. The first thing that struck me was the walls; at Seaford, the inside of the tower has been completely whitewashed concealing the thousands of locally made red bricks that make up the tower.

It was interesting to see the magazine where the cannonballs and powder were kept: at the rear of the four powder alcoves were holes that lead outwards. They were designed to disseminate any accidental explosion.

Access to the upper floors is via brightly coloured metal spiral staircases. The view from the roof is stunning, perhaps one of the best in Eastbourne – what a shame that so few get to see it.

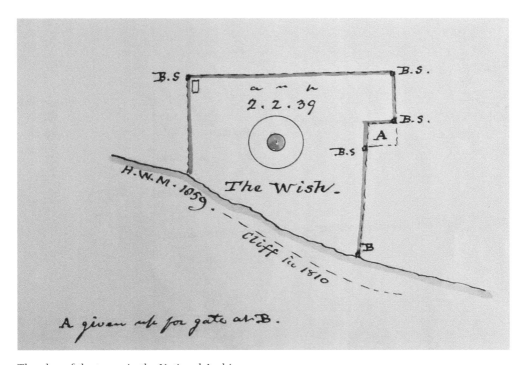

The plan of the tower in the National Archives.

The author on top of the Wish Tower.

The tower itself is in a poor condition. It is sad that, although many of the original features are still in situ, it has been allowed to deteriorate. In 1961, a café and sun lounge were built adjacent to the tower and it was regularly packed. The café was built as a war memorial and was funded by the Foyle family (of bookshop fame) but was demolished in 2012. I can remember sitting on the edge of the nearby ornamental pond licking a '99' ice cream and watching the large goldfish while my parents had a cup of tea inside the café – happy days!

But all is not lost. The Friends of the Wish Tower have been active in raising funds and there are plans for a new café. In March 2018, an 8-ton lump of granite was carefully lowered into the dry moat. This will become a memorial to the 180 Eastbourne civilians who lost their lives in the Second World War.

War memorials come in all shapes and sizes. One of the victims who will be mentioned on the memorial was a cousin of mine, Henrietta Hannah Louisa Hollebon, who was killed at No. 3 Brightland Road during an enemy raid on 7 March 1943. She left money in her will to my great-grandfather Ebenezer, who used it to build an inside bathroom in the family home at No. 8 Annington Road. I remember seeing the brass letters 'H.H.L.H.' over the bathroom door. I am pleased that a more suitable war memorial will now be put in place, but I wonder if the new owners of my great-grandparent's house realise that they have a war memorial bathroom.

Work has already started on landscaping the area around the new memorial and if a new café can be built and the tower reopened to the public, then the whole area can become a suitable memorial and a focal point for residents and visitors alike.

The creation of the new war memorial and garden.

Goats, Ponies and Donkeys

From the Wish Tower walk back to the main road, Grand Parade.

Two stones marked with the broad arrow – the sign of the War Department – are inset into the low wall. If you look closely, though, there are some other markers too. The Public Health Act of 1875 required Eastbourne Council to license the hiring of animals and public vehicles. They designated stands around the town where such public transport could be hired. The small metal marker plates were set into the kerb and you will see several of these at this point. 'HCS' is a Hackney Carriage Stand, which was a horse-drawn taxi. 'BCS' is a Bath Chair Stand. A bath chair was usually used by infirm people and was akin to a large wheelchair, with two wheels at the back and a single steerable wheel at the front. Usually this would be pulled and steered by the attendant, but if required the steering handle could be turned around to allow the passenger to steer and the attendant would have to push from the back. 'SDS' was a Saddled Donkey Stand and a 'GCS' was a Goat Chaise Stand. These were smaller vehicles for giving children a ride.

The saddled goat chaise marker is particularly interesting to me as on the 1881 national census Ebenezer Robert's occupation was 'Driver of a Goat Chaise'. He was only fourteen years old himself but earned a living by giving taxi rides to children. Today I can stand on exactly the same spot where I know my great-grandfather stood nearly 140 years ago.

There are several similar plates around the town, including 'SPS' for a Saddled Pony Stand and 'LPS' for a Luggage Porter Stand. Another version to be seen on the wall near the Wish Tower is 'MCS' for a Motor Charabanc Stand. I wonder if my great-great-uncle William Vinall used to ply for hire here too?

Left: The Wish Tower with the Saddled Donkey Stand marker to the lower left.

Below left: Hackney Carriage Stand.

Below right: Goat Chaise Stand.

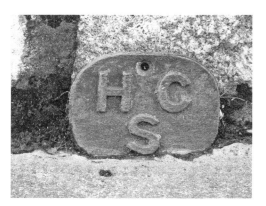

DID YOU KNOW?
In 1906 and 1910 applications were made to the Town Hall to licence a number of Chinese rickshaws pulled by men dressed as 'Oriental Coolies'. The applications were made.

Before we continue our walk, have a closer look at the pillar box on the corner of Grand Parade and Wilmington Square. It is most unusual as it does not have a royal cypher on it. This 'blind' pillar box would have been one of the first to be installed in Eastbourne and dates from between 1879 and 1885. It was made by the firm Handyside & Co., who made the fountain we saw earlier in the walk.

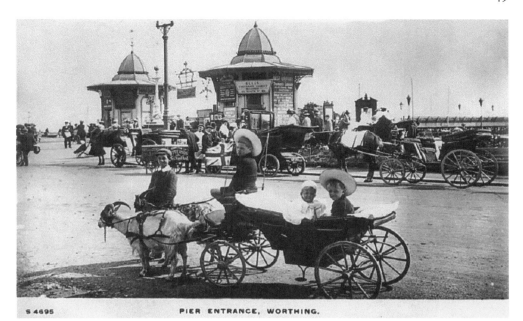

A goat chaise at Worthing Pier.

Fashion and Fracas

The land around the Wish Tower was very popular in the summer, particularly on a Sunday afternoon when thousands of residents and visitors, having attended church, would gather 'to be seen'. Ladies particularly would ensure that they were dressed in the most up-to-date fashions.

Newspapers printed regular columns advising what was in vogue. A woman was expected to have different outfits for travelling, dining, bathing and general wear. Travelling light was out of the question. No wonder there were so many luggage porters needed to carry the heavy trunks from the station to the hotels.

An example is given from the *Ladies Signal* newspaper of August 1896:

WHAT TO WEAR FOR THE SEASIDE
The choice of a seaside outfit is rather a difficult matter when one is paying a visit to a place for the first time. Every seaside place has its own fashions, and the dress that looks well in one locality is totally inappropriate for another. Supposing one is going to Eastbourne, a number of dresses will be required as it is the fashion to make a fresh toilette three or four times a day.

A dainty dress is needed for wear on the parade in the morning; pink looks particularly well on the parade and one sees linen and cambric dresses in white, holland colour, pale blue, scarlet, mauve and every colour under the rainbow. A bright day brings these dainty dresses as sure as the sun brings out flowers but there must also be those heavier in stock with a view to a dull or chilly day. It is then that the tailor-made gown arises in its glory, the simple tweed mixture in fawn and pink or brown and blue, or, better

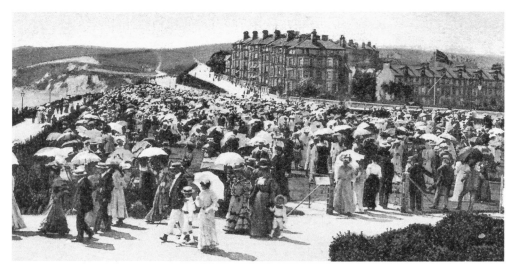

The Western Lawns fashion parade.

still the navy serge yachting suit, enlivened with a little gold trimming or softened by a purple silk sash.

The afternoon is usually spent in watching the tennis players in the Devonshire Park and here one must wear as smart a dress as one would choose for the Eton or Harrow day at Lord's.

One would not buy new afternoon dresses for Eastbourne, but one would finish out the visiting-gowns which had served their purpose in London during the season. The comfortable tea-gown is slipped on for dinner, and, if one is going to a concert at Devonshire Park in the evening another change is requisite. People wear much the same kind of dress which would be worn in a foreign casino – smart hats with an abundance of flowers, pink muslin dresses, foulards or mousseline-de-laines, elbow sleeves and long white gloves. A dressy wrap is carried on the arm, as it may be chilly when one leaves the concert room. Short capes in royal blue cloth are very appropriate, though some people like a feather boa or a sable tie, or one of the large French ruffles made of chiffon, lace or flowers.

The Western Lawns opposite the Grand Hotel was the main place to be seen, and on a Sunday summer's afternoon thousands would gather here for a genteel and peaceful parade in the sunshine to show off one's latest apparel.

In Eastbourne, this peace and quiet was proscribed by law: Section 169 of the Eastbourne Improvement Act 1885 forbade the playing of musical instruments in public on the Sabbath. This suited everyone except for one small group of people: the Salvation Army, who had established an Eastbourne branch in 1890.

These 'Sunday Leaguers' started to parade through the town, often ending up near the Wish Tower where they would hold an open-air service. The noise of their instruments disturbed many people who wanted a nice quiet afternoon stroll, and many were quite vocal in their opposition.

The problems started early in 1891 when complaints were made to the Eastbourne Watch Committee about the Salvation Army singing in the streets. One lady complained that they would not stop singing outside her house even after she had asked them to desist as a resident was ill. There had regularly been complaints that the Salvation Army were causing an obstruction by blocking roads with their meetings.

The Eastbourne Borough Police had been formed on 5 April 1891 and one of the very first problems for the new chief constable, John Fraser (formally the head of the High Wycombe Police in Buckinghamshire), was the Salvation Army.

An open letter to the chief constable from a Mr W. Moore was published in the *Eastbourne Gazette* on 29 April 1891:

Sir,
Hearing that it is the intention of the Salvation Army to defy the Bye-Laws of our quiet town. I beg to state on behalf of myself and other rate-payers that, if this mockery of religion, that is the Salvation Army, intend to defy all law and order, it is my intention to counter act their defiance of the law by peaceable means if possible. It is our intention to march alongside the Salvation Army but not to interfere with them. What is sauce

ANOTHER EASTBOURNE RECRUIT.

A Salvation Army caricature.

for the goose is sauce for the gander. You, being an entire stranger to Eastbourne, we are determined by all lawful means to support you. We do not allow the Salvation Army to overrule our Head and Chief.

Yours respectfully, W. Moore

As a result of this letter the new chief constable summonsed Mr Moore and he was bound over by the magistrates to be of good behaviour. The Salvation Army decided not only to defy the law, but to exacerbate the situation by forming a brass band to make their processions even noisier!

DID YOU KNOW?
The building on the corner of Latimer Road and Halton Road used to be a police station. If you look closely you can still see the Eastbourne Police Crest above the door.

The band played for the first time on Whit Sunday 17 May 1891, when it headed a procession from their citadel in Ashford Road to boos and hisses from around sixty local people. It did not get far, as Chief Constable Fraser pushed through the crowd and stood in front of the Salvation Army Captain Bell. To quote a Salvation Army source: 'This spectacle was not without its humorous side. On one hand, there was the Chief Constable standing in a NAPOLEONIC posture with gloved hand lifted. Facing him stood the slim figure of Captain Bell.'

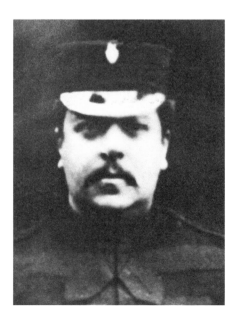

Chief Constable John Fraser.

Bell was duly summonsed and received a fine of £5, or one month in Lewes Prison. The *Eastbourne Gazette* editorial reported:

No one can seriously contend that a Salvation Army Band on Sundays is necessary here. The Army has received a great deal of support in the town and should show its gratitude by resolving not to disturb the peace and it would be wise for the Salvationists not to take a course of action that would alienate many of its supporters. The Salvationists live to a great extent on opposition. A series of disturbances and prosecutions here would be a godsend to General Booth and would probably cause his coffers to be replenished. We also protest against any attempts to inflame the public mind over a miserable squabble which cannot be of advantage to the town. Eastbourne has its own police and mob-rule cannot be tolerated here.

This 'miserable squabble' was the start of an escalating series of events, when every Sunday more and more people turned up to both support and oppose the Salvation Army processions.

The Salvation Army chose the Wish Tower slopes for its Sunday services, which met with more and more opposition. On one occasion over 7,000 people turned up to oppose them, with the police describing several of these confrontations as 'riots'. Again, quoting a Salvation Army source:

As the tide of opposition grew, the town became a centre of people coming from all directions, some as far as London, from Worthing in the west and Rye in the east and all the towns and villages between. They came in thousands to look on or take part in the 'fun' and all the rough elements from everywhere joined forces with them. They came by road, on bicycles, horse-and trap, walking, by rail excursion – anyhow as long as they could get to Eastbourne. There were navvies and farm-workers who came just as they were from their work who carried their stick which they had cut out of the hedges. They made a real afternoon of it. The cursing and swearing, boos, hoots, whistles coupled with rotten eggs, flour, fish-guts, rotten fruit and vegetables were all thrown at us but it did not daunt any.

It must have been frightening for the Salvationists. Alfred Gillard wrote about one Sunday disturbance that was witnessed by the mayor, the chief constable and the local MP. That Sunday the procession was from Ashford Road and was accompanied by a dozen police officers.

At the Wish Tower, the crowd increased until there were over 1,000 lining the slopes. The bandsmen accompanied the first hymn on instruments but at this the crowd groaned and hooted. A rush was made at the band but it was easily checked by the police. The crowd booed throughout the service and before the meeting closed another rush was made, which, if it was not for the presence of the police, serious danger to limb would have resulted.

They were not always lucky to have the protection of the police. Salvationist Walter Guy wrote: 'One Sunday we were at the Wish Tower slipway and had a terrific rowdy time. The crowd were extra violent and the noise and the shouts were deafening. After the open-air service, we made a move to go up onto the road but we were prevented and had to go along the lower parade.' He tells that this was a ploy by the mob, who then proceeded to push the band members off the parade onto the beach – a drop of some 5 feet.

The Watch Committee issued a ban on the Salvation Army holding meetings at the Wish Tower, but on the following Sunday it was ignored. Walter Guy continues,

> When we got to the slope [of the Wish Tower] we found a cordon of police shoulder to shoulder across the road. We with our flag came crashing up against the police. As we struck the police line one big constable caught me by the shoulders and gave me a violent push backwards but we pushed them out of the way and went down onto the beach.

Many Salvationists went to court and were imprisoned. Things came to a head when the Eastbourne mayor (William Morrison) ordered the arrest of the Salvation Army Band. Ironically, the band that week were visiting from Camberwell in London. (As a former police officer myself, I suspect that this was one of the noisiest arrests ever made!)

The justices tried to reach a compromise by suggesting that the Salvation Army paraded on alternate weekends, so that Eastbourne people could have some quiet Sundays. The Salvation Army refused. A referendum was held and proved that the vast majority of local people supported the Eastbourne authorities with their stance on the Salvation Army.

What exactly was going on? Firstly, it should be noted that the Salvation Army of 1891 was not the same as it is today. It was a relatively new organisation then, having been established in London by William Booth and his wife Catherine a few years earlier. Their main converts were alcoholics, drug addicts, prostitutes and other undesirable people who were unwelcome by the regular churches at that time. They were strictly teetotal and spoke publically against the evils of alcohol. At this time, before radios or televisions, the pub was very much the centre of evening entertainment. Obviously, the many publicans in Eastbourne were concerned about the Salvationist stance affecting their trade. There were reports (for instance in Worthing) of the Salvation Army holding meetings outside pubs and the Church of England in Dover complained that the local Salvation Army band were disrupting their own church services.

A shady organisation called the Skeleton Army had been established in London in 1891 with a mandate to oppose the Salvation Army. They followed Salvation Army parades carrying skull and crossbone banners, and tried to disrupt church meetings. Splinter groups were established in Worthing and several West Country towns. Although there are no reports of a Skeleton Army in Eastbourne it is more than likely that they had some influence in the proceedings.

Borough of Eastbourne.

SALVATION ARMY.

The Watch Committee earnestly request all the inhabitants of Eastbourne, who wish to assist them in their efforts to prevent the Salvation Army from committing a breach of the law by forming processions on Sundays, accompanied by instrumental music,

TO REFRAIN FROM

HURTING, MOLESTING OR OPPRESSING

THE MEMBERS OF THE ARMY, OR

ACCOMPANYING OR WATCHING ITS PROCESSIONS.

By remaining at home or otherwise acting as if the processions were not taking place, law-abiding Burgesses may do very much to aid the Committee, who are taking legal measures to restrain the Members of the Army from persisting in their intentions to break the law, and defy the Authorities by forming the unlawful processions referred to.

The Committee desire the inhabitants to rest assured that they will use every legitimate means for preserving the public peace, and preventing these breaches of the Law.

W. E. MORRISON, *Mayor.*

H. WEST FOVARGUE, *Town Clerk.*

29th May, 1891.

The Committee wish it to be observed that in their opinion all individuals joining in the processions will be liable to the penalties imposed by the Act.

V. T. Sumfield, Steam Printer and Lithographer, Station St., Eastbourne.

The council attempt to quell the disturbances.

The Salvation Army Band (Walter Guy is fourth from the left on the back row).

An Undemocratic Solution

The Salvation Army had many friends in Parliament and informed the Town Council in November 1891 that they would introduce a bill to repeal the bye-law that prevented their marching. Despite the local MP, Admiral Edward Field, speaking forcibly about this undemocratic approach, the bill eventually received royal consent and the disturbances ceased.

I have read a good deal about these disturbances and it is interesting to see how the Salvation Army have rather skewed the history of them. They speak about the Eastbourne disturbances being 'a long and bitter struggle for freedom' and of the 'righteousness of their cause'. But what was their cause?

There is no suggestion of opposition to the 'cause' of what the Salvation Army stood for among the vast majority of Eastbourne people. Like my great-grandfather, the majority of locals were God-fearing, churchgoing Christians. If the Army had marched without musical instruments they would not have been breaking the law and there would have been no trouble. There seems to have been an element of bloody-mindedness about their stance and their refusal to negotiate a compromise with the authorities. Maybe the *Eastbourne Gazette* was correct in intimating that the newly founded Salvation Army was after some publicity.

I worked closely with the Salvation Army when I was a police officer in London and their work, particularly following disasters, was truly amazing. However, a few years ago I was annoyed that the official Salvation Army website, in mentioning the good people of Eastbourne, described them as 'Godless'. I contacted them and was invited to give a presentation at their HQ at Elephant & Castle in London. The website was duly changed.

The 8th Duke of Devonshire

Today the Western Lawns are quiet, even on a Sunday afternoon, and often the only 'person' to be seen is the statue of Spencer Compton, the 8th Duke of Devonshire (also known as Lord Cavendish and the Marquess of Hartington). Like his father, he is dressed in the robes of the Chancellor of Cambridge University. I have a photograph of the statue when it was still in the studio of the sculptor Alfred Drury. There are many works by Drury around the country but he was most famous for his frieze above the entrance to the Victoria and Albert Museum and also the statue of Sir Joshua Reynolds in the courtyard of the Royal Academy.

The statue of the 8th Duke of Devonshire.

Alfred Drury in his studio.

Eastbourne has much to thank the 7th and 8th Dukes of Devonshire for, as they put a lot of their own money into improving the town. They have left an everlasting legacy to the town as dozens of Eastbourne roads are named after them, members of their family, or the villages near their stately home – Chatsworth House in Derbyshire. The dukes were clearly highly regarded by Eastbournians as both statues were paid for by local townsfolk.

A Secret in the Shingle

If you were here on the Western Lawns, opposite the Grand Hotel, just after 6 p.m. on the evening of Wednesday 9 October 1912, you would have seen the solitary figure of a heavily pregnant Florence Seymour waiting on a bench for her boyfriend to return and take her back home to Latimer Road. It was probably quite cold. When her boyfriend, George MacKay, did return – shortly after 7 p.m. – he was flustered and in a hurry. He was not wearing his cap and dashed down onto the beach where he hurriedly buried a sack in the shingle. The secret in the sack was to be a vital piece of evidence in a murder trial.

Sixty-two-year-old Countess Sztaray lived at No. 6 South Cliff Avenue, just to the west of the Grand Hotel. Her name sounds exotic but her first names were Flora Ruth and she had been born in Canterbury, the only child of Count Ladislas Sztaray, formerly of the Austrian Imperial Cuirassiers (later a captain in the British German Legion) and his English-born wife, Julia.

At the same time that Florence Seymour was waiting on the beach, Countess Sztaray left her house for a dinner appointment, but as she got into her carriage she noticed a man

South Cliff Avenue. The countess lived in the house marked by the right-hand asterisk.

on the porch above the front door trying to break into an upstairs window. She returned to her house and telephoned the police station (telephone number Eastbourne 13), saying: 'Will a Constable come at once as we have a man breaking into the bedroom window over the front door.' Constable John Luck took the call and relayed the message to Inspector Arthur Walls, who was at his office on Grand Parade. He said, 'I will go at once'. The call was logged at 6.50 p.m.

Inspector Arthur Walls was married with three children. He lived with his wife Emily and three sisters-in-law in Cavendish Avenue. He had joined the East Sussex Constabulary twenty-four years earlier but had transferred to the Eastbourne Borough force shortly after it was established. His role in the force was that of 'parade inspector' and he was responsible for the seafront.

DID YOU KNOW?

The police parade inspector had a variety of jobs, including the licensing of fishermen and the owners of the pleasure boats. During the Second World War their role changed to keeping a look out for and supervising the destruction of the many mines that were washed ashore.

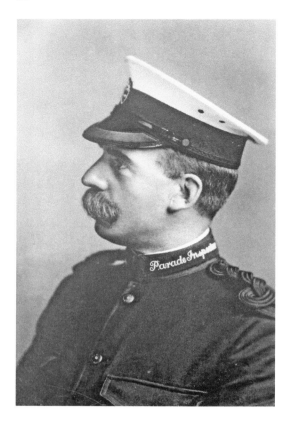

Police Inspector Arthur Walls.

Inspector Walls was soon on the scene of the burglary and called up at the man, 'Here old chap – come down!' He was answered with two shots from a revolver; the first hit him in the chest and, as he staggered backwards, another hit him in the leg. He died soon afterwards. PC Luck at the police station received a frantic phone call from the house: 'There is a murder being done – send someone on a bicycle!'

Several officers, including Chief Constable Major Edward Teale, were soon at the scene. He authorised his officers to carry firearms while they searched the area. Unfortunately, the search failed to find George MacKay and Florence Seymour.

The chief constable was under a massive amount of pressure that evening. The previous day he had been in the divorce court seeking a separation from his wife, who had been living with another man in a hotel in London. He had been the chief constable of Eastbourne for twelve years and prior to that had been a major in the Duke of Cornwall's Light Infantry. This was the second murder case that he had dealt with in just eight weeks. In August a gunman had killed four people in a house in Enys Road, but the man had turned the gun on himself so there was no one to be arrested.

That evening he decided to call in the murder squad from London. This was a brave decision. They had been established just five years earlier to investigate homicides within the metropolis, but would also assist county forces if requested. Many chief constables

Chief Constable Edward Teale.

did not wish to admit that a crime in their area was too difficult for their own detectives to investigate and were often slow to call in the services of the Metropolitan Police. This was not so for Major Teale.

DCI Bower and DS Flayman arrived from London the very next morning and arranged for a thorough search of the murder scene. A cloth cap was found as were several footprints in the flower beds, which were preserved in plaster.

The murderer, George MacKay, escaped to London. He described himself as a sculptor, but had previous convictions for burglary. He often used the alias John Williams. His girlfriend Florence confided in a mutual friend, Edgar Power, and he persuaded her to take him to the place on the beach where the sack had been buried; however, he had also told the police and so she was arrested. The sack was retrieved and it contained some rope and the murder weapon. MacKay was arrested and bought back down to Eastbourne. He admitted to 'casing' the house but not to the actual murder. His baby was born a few days later but Florence was so unpopular in Eastbourne that local hospitals refused to take her in so the baby was born in Hastings.

Inspector Walls was buried on 16 October 1912 at Ocklynge Cemetery. It was a massive funeral and most shops in the town closed for the day as a mark of respect.

MacKay was subsequently found guilty at Lewes Assizes and was executed in the prison. Before his execution he was allowed to kiss his baby and gave the child a small piece of prison bread, saying: 'Now you can never say your father never gave you anything.'

George MacKay.

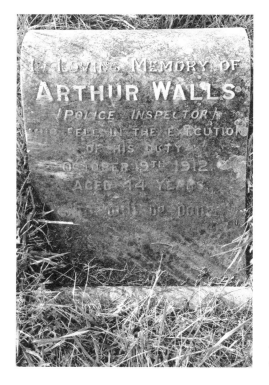

The grave of Inspector Walls, Ocklynge Cemetery.

The Western Parades

The area between the Wish Tower and Meads was called the Hobby and the hill where the obtrusive South Cliff Tower now stands was called Hobby Bank. It is seen here in a photograph taken around 1870. Note the camera obscura in the foreground. The tall building is Earp's Folly, later the Cliff School. The spire of St John's Church can be seen on the right.

It was the 7th Duke of Devonshire who funded the creation of the Western Parades between the Wish Tower and Holywell. The scale of works was phenomenal, with over 400,000 tons of chalk, shingle and 'Eastbourne greensand' having to be removed. The work started in 1881 with the intention of extending the parade to the foot of Beachy Head. Letters to the paper compared the work to the construction of the polders of the Zuider Zee in Holland and, when a delegation from Brighton Town Council visited Eastbourne in May 1882, it was said that the new promenades and carriage drives 'excited their admiration and were viewed with a jealous eye as the magnificent parades, when finished will out-rival Madeira Walk of Brighton and the flat ornamental parterres of Hove'.

Today the Western Parades make an ideal stroll, but it should be remembered that one was a carriage drive to enable the rich well-to-do visitor a pleasant and secluded (and maybe romantic) drive after dinner without encountering the ordinary residents of the town. The parades were fit for a king! Indeed, they were regularly visited by George V and Queen Mary during their stay at Compton Place in March 1935.

Hobby Bank.

The king and queen on the Western Parades.

The royal beach hut.

The king was in poor health but seemed to enjoy his walks here, stopping occasionally to pat dogs who were being taken for a walk. The queen did not always accompany her husband, seeming to prefer motor trips to Seaford, Alfriston and the surrounding countryside. A beach hut was put aside for Their Majesties' to rest and this is today marked with a commemorative plaque.

There were concerns at the Town Hall that large groups of people were deciding to use the parades with a view to catching a glimpse of the royal couple. The mayor said that that it was a matter of regret that the large crowds displayed little or no respect for Their Majesties' privacy; however, he thought that the majority of local residents had a good name and that a large proportion of the crowds were actually visitors who were in town for the day.

A council resolution was passed 'that the council tender their loyal and respectful greetings to their Majesties and express the hope that their stay in Eastbourne would be beneficial to their health'. The king died a few months later.

A Holy Well and a Chapel

We are now in Meads, one of the five original villages that made up Eastbourne. The others were Upwick (now Old Town), Upperton, Esthall – also called South Bourne (around where the Town Hall now stands) – and Seahouses, close to where we started our walk.

The area at the end of the parade is known as Holywell but locals know that it is pronounced 'holly-well'. There is certainly a well in the area and early guidebooks mention a chalybeate spring – a mineral spring containing salts of iron, similar to the ones at Tunbridge Wells. An 1868 guidebook says 'the water [at Holywell] is seen to distil from the rock; trickling down and in some places dripping copiously with a tinkling sound and forming little rivulets which lose themselves amongst the shingle. The water is very fresh – clear as crystal and cool and delicious to the taste'.

We also know that there was a chapel in the area dedicated to St Gregory (the patron saint of lost keys). This was first mentioned in the year 1248. This chapel was probably a chantry, a building where the incumbent clergyman was paid from bequests to say prayers to the departed to quicken their journey to heaven. There probably would have been a small collection of houses around the chapel; indeed, until around 100 years ago there was a hidden village under the cliffs here, occupied by fishermen and limeburners. (Limeburners used kilns to burn the chalk to make lime, which is used by the building industry as a stabiliser for mortar and also has agricultural applications.) The village was abandoned around 1895 when a waterworks where established nearby.

A document dated 1353 mentions the 'Chapel of Saint Gregory of Estbourne – for this chantry the said vicar received from the sea-faring men there a certain custom called Cryst-share'. Before a fishing boat went to sea in medieval times, an agreement would be made as to the share of the catch. The catch was not only divided among the crew but also between the boat owner, the owner of the nets and the local church. This was the maritime version of paying tithes and, of course, was called the 'Christ share'.

At the end of the prom and adjacent to the popular café (built in 1921) is the old 'Gore chalk-pit'. It was on the nearby beach that a cross-Channel telegraph cable came ashore.

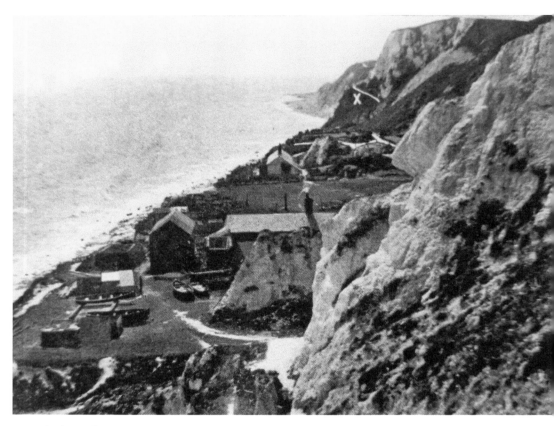

The lost village of Holywell.

It was connected in 1861 and linked Paris and London. The chalk pit was transformed into a formal garden in 1904. The small hut with the pergola at the entrance (behind the café) was the cable hut. Sadly there is no evidence inside of its previous use, although cables do still come ashore here; the last to be connected was in 1978. When further buildings were added in 1922 (which in the early days were the venue for local bands) this area became known as the Italian Gardens.

Above the Italian Gardens are the Helen Gardens, with its miniature golf course and bowling greens. A footpath just before Bede's School leads down to the beach. This used to be one of my favourite places when I was young. An uneven chalk path takes one down to a secret and secluded beach. Not only is there sand here at low tide, but also plenty of rock pools full of marine life to explore.

Tourists would have flocked to the area to see the imposing cliffs. The steady erosion of the cliff face, with regular rockfalls gave rise to pinnacles being created in this area. In the early 1800s people came to see the Three Charles's and later the Devils Chimney, but these have now fallen into the sea. When I was young you could climb atop the pinnacle known as the Sugar Loaf here, but when I last visited it had been fenced off.

The towering cliffs of Beachy Head.

DID YOU KNOW?

The Battle of Beachy Head was fought between the French and a combined English and Dutch fleet on 10 July 1690. The English were trounced and several allied ships were lost. There is one survivor in the form of an old Dutch ship's figurehead – now on display at Alfriston.

3. Inland to the Old Town

We will walk to the Old Town via Meads.

Although it was one of the earliest parts of Eastbourne, Meads rapidly developed in the 1880s following the work on the Western Parades. In 1868, *the Hand-book for Visitors to Eastbourne* says: 'Meads is at present only a poor agricultural hamlet, but extensive building operations are planned and it will probably eventually become the Belgravia of Eastbourne.'

> DID YOU KNOW?
> Eastbourne was the first town in the world to provide a municipal bus service. It set off from the railway station to Meads on 12 April 1903. By 1910 the town was operating twenty-three open-topped buses.

However, the *Eastbourne Gazette* of March 1884 reports that 'the whole district from Holywell Mount to Meads is rapidly being covered with dwellings more or less handsome, and when the trees which have been planted by the side of every road, have grown and form noble avenues, and their spreading branches offer a delightful shade during the heat of the summer, this part of the town will present a most picturesque spectacle.'

I used to enjoy visiting the two Meads pubs; the Pilot is a Victorian pub dating from 1855 and usually good for a lunchtime meal, however the Ship is on the site of a much earlier tavern that was around in the seventeenth century.

Both are good pubs but an evening visit usually meant a dark walk through Meads, up Gaudick Road and across the golf course to get home. At the time I didn't realise that this path had been trodden by my ancestors for centuries before. The word 'Gaudick' is a corruption of 'gore-dyke', which probably means a triangular field next to a dyke.

The Eastbourne Golf Club attained its 'Royal' status when HRH Prince Albert Victor of Wales, Queen Victoria's grandson, became a member in 1887. In 1893 Princess Louise (later the Princess Royal), the eldest daughter of Edward VII, became a member of the ladies club and it became the very first ladies golf club to achieve royal status.

A notable member of the golf club was Arthur Balfour, the first prime minister of the twentieth century. It is not surprising that Balfour was a member of the club as he had a most relaxed view of politics and many did not think he took his job seriously. People wondered how he had become prime minister, although the fact that he was the nephew of the previous one, Lord Robert of Salisbury, probably had something to do with it.

Above: The Ship Inn, Meads.

Right: Prime Minister Arthur Balfour.

Balfour was so effete that he gained the nicknames Miss Balfour and Pretty Fanny and his sudden rise in government, thanks to his uncle Robert, was the origin of the phase 'Bob's your uncle!'

As you walk inland across the golf course, keeping carefully to the footpath, you have the downland known as Paradise to your left and the grounds of Compton Place to your right.

Compton Place – A House with Two Saints

Although there has been a building here for centuries, the present house was built in 1726 for Spencer Compton, Earl of Wilmington. Although the house and grounds are still owned by the Dukes of Devonshire, the family have now retreated back to Chatsworth House following the death of the 10th Duke in 1950. Since 1954, their former holiday home has been used as a 'finishing school for ladies' and as a language school.

The building is occasionally opened for guided tours and the enthusiastic and knowledgeable staff seem proud to be associated with the Grade I-listed building. To be honest, the years of children dashing around the corridors has taken its toll, although luckily, as most children are short, only up to a certain level. The lower panelled walls are often scuffed but above shoulder height there is some stunning pale blue rococo-style stucco work, particularly in the upper rooms where the classrooms were previously bedrooms.

I have already mentioned that George V stayed here for six weeks in 1935, but he was not the only royal visitor. George III stayed here during the summer of 1780 (if you remember his children stayed at Field House on the seafront). Our own Queen Elizabeth stayed here in 1936 and again for two weeks in 1946 when she visited with her sister, Princess Margaret.

Compton Place.

The stucco work at Compton Place.

Alix Leaves Her Mark

On 21 August 1878, a royal party arrived at Eastbourne from the Isle of Wight. This group consisted of Louis IV, the Grand Duke of Hesse, and his wife Princess Alice, the Grand

Duchess of Hesse. Princess Alice was the second daughter of Queen Victoria and had been visiting her mother at Osborne House. The couple were travelling on the royal yacht, *Alberta*, with three of their children, the Hereditary Grand Duke and the princesses Alexandra and Marie of Hesse.

While in Eastbourne the royal party stayed at Compton Place. It was a house known to them as they had stayed there a few weeks earlier in July. On this occasion, they stayed in Eastbourne until 4 September but it was to be Princess Alice's last visit; she died of diphtheria later that year on 14 December 1878. Eastbourne were proud that the queen's daughter chose the resort for her holidays and commemorated her death with the Memorial Hospital in Carew Road.

Princess Alexandra also caught diphtheria. She would not only survive but returned to Eastbourne again when she was also to leave a permanent reminder of her stay.

Princess Alexandra was born on 6 June 1872 and baptised as 'Her Grand Ducal Highness, Princess Alexandra Victoria Helena Louise Beatrice of Hesse and the Rhine'. She was a bright and active girl and was known by the nickname Sunny, although she preferred the name Alix.

Queen Victoria adored her grandchildren and mentions Alix in her journals on many occasions but, as she had several other Alexandra's in her vast family, she called her Alicky. In 1875, the queen described her grandaughter as 'dear, beautiful and amusing' and tried to sketch her, but the toddler would not keep still. In 1878, the year she came to Eastbourne, Victoria described Alicky as 'a glorious child, handsomer than ever and a great darling with brilliant colouring, splendid eyes and a sweet smile'.

After her mother, Princess Alice, died in 1878, Alix spent many holidays in England. Her father Louis (who the previous year had become Grand Duke Ludwig IV) died in April 1892. Alix was distraught and returned to England to stay with the Dukes of Devonshire in Compton Place for the summer, before travelling up to Balmoral where she stayed with her grandmother, the queen.

How did Alix feel when she was in Eastbourne? She was twenty years old and must have been lonely, sad and bored. She was under pressure from her grandmother to get married to her cousin, Prince Albert Victor, the Duke of Clarence. He was rather a cad, and later to be a suspect in the notorious Jack the Ripper murders.

Her bedroom in Compton Place was (and still is) sumptuously decorated. Pevsner, the architectural critic, complained that the bedrooms were over decorated, but did Alix notice the decoration as she looked over the fine gardens towards the sea? Was she pondering her future?

In her boredom, she scratched her name and date on the window, most probably with her diamond ring. Alix was in love. She had fallen in love with a distant relative several years before. Her beloved was no less than Nicholas, the heir to the Russian throne. They were married in 1894, two years after her last stay in Eastbourne. Two years after that (with her husband now Tzar Nicholas II) she was crowned and became the Empress of Russia.

Nicholas and Alexandra had five children, their last being Alexei, the heir to the throne. Alexei was a sickly child and suffered from haemophilia. When doctors failed to heal the child, his mother looked to alternative cures and fell under the spell of the mysterious mystic Grigori Rasputin.

Above: An empress leaves her mark.

Right: Saint Alexandra, Empress of Russia.

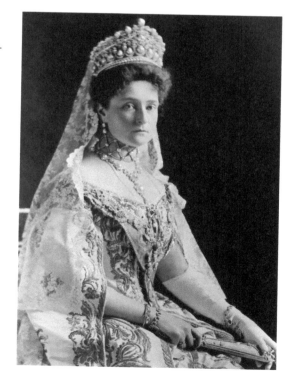

During the First World War, the tzar took personal control of the Russian military to leave his wife Alexandra in charge of the government. The war with Germany was a disaster for Russia and Alexandra – who, after all, was German herself – was blamed for the economic decline of a once great power. There were food shortages and millions starved.

The Revolution of 1917 saw Nicholas, Alexandra and their children deposed. They begged to be exiled to England but our own George V, worried about their unpopularity, declined. They were placed under house arrest and sent to a palace near St Petersburg.

One hundred years ago, on 17 July 1918, revolutionary guards burst into their room and summarily executed the whole family. Her husband and two servants were killed in front of her and, as she made the sign of the cross, she was also shot. The Russian royal dynasty had ended.

A few years ago, the remains of the family were formally identified. She was the great-aunt of Prince Phillip and he provided a DNA sample to aid the identification. Alexandra and her family were finally buried at St Petersburg Cathedral. In 2000, Alexandra was canonised by the Russian Orthodox Church and is now known as Saint Alexandra the Passion Bearer.

Do the students who now use the State Bedroom in Compton Place as a classroom realise the room has something precious and unique? The etched graffiti 'ALIX 1892' is a sad reminder of her stay in Eastbourne. It must be the only place in the world where you can see graffiti scratched by a saint!

A Massage for the Blue Boys

During the First World War, Compton Place was occupied by another 'saint' who was known as the Angel of Summerdown. She was an American called Pauline Whitney. Pauline had inherited millions of dollars in the will of her father, who had owned the Standard Oil Company in the USA. In 1895, she married Englishman Almeric Hugh Paget in a lavish ceremony in New York – even the American president Grover Cleveland attended. The couple settled in England.

At the outbreak of the war in August 1914, Almeric and Pauline offered fifty trained masseuses to provide physiotherapy to wounded soldiers. They formed the corps known as the Almeric Paget's Military Massage Corps, and in May 1915 a unit was opened at the Summerdown Military Camp in Eastbourne.

The Summerdown Camp had been established off the East Dean Road to accommodate and rehabilitate over 3,000 wounded soldiers. These men were issued with light blue uniforms and became known as the Blue Boys. Between May and October 1915, the APMMC had treated 1,972 wounded men at Eastbourne.

During the war years, Almeric Paget was the busy MP for Cambridge, but his wife Pauline stayed at Compton Place and regularly visited the camp, chatting to the soldiers and even playing cards with them.

In the *Summerdown Camp Journal* of September 1915 (which, by the way, was printed by my great-great-uncle, Bert Bennet) the editor spoke highly of Mrs Paget:

Right: An Eastbourne 'Blue Boy'.

Below: Pauline Paget.

Words fail us to enlarge upon the kindness and generosity of Mrs Paget, the genial hostess of Compton Place. She lives simply and solely to cheer and brighten the lives of the convalescents. Nothing seems to escape her, which may add to their happiness, nor does she ever fail to throw herself heart and soul into every entertainment that she arranges for their pleasure, mixing and chatting freely to one and all. We wonder if she realises just what her kindness and genial presence has meant to hundreds of convalescents. I overheard a man say 'God Bless her, she is the genuine article' and we heartily re-echo his words. It would take too long to mention the many things, that we, or rather the whole army are indebted to Mrs Paget. We feel that every man should know that the massage establishments, erected in all Convalescent Camps, are run at Mrs Paget's expense, also that our Camp Band, equipped with the very best instruments to be had, is another example of this good lady's generosity.

The lawn of Compton Place is graced with a magnificent cannon, said to have come from one of the Martello towers.

The Compton cannon.

4. Old Town

If you are walking from Meads you will enter Old Town via Compton Place Road, which becomes Borough Lane. This is named from the burgh that was a meeting place in Saxon times, probably the centre of local government. To the west, Vicarage Road and Greys Road were previously Borough Laine. A 'laine' was a large field.

The Greys.

Secrets of Greys Road

On the left, opposite the entrance to Manor Gardens, once stood a large house called the Greys, the home of the Willard Magistrates (*see* page 23). A quick walk up the road will reveal a couple of interesting things. (And I don't mean my Mum and Dad, who live there!)

The original (top) part of Greys Road was built in 1905 and was a cul-de-sac that led from Vicarage Road down to the high garden wall of the Greys. When the Greys was demolished in 1910 another road was built up from Borough Lane. This was called The Greys and was separated from Greys Road by the old garden wall, which formed a

barricade. This was the case for many years until the barricade was pulled down and the two roads were united to become Greys Road. This unusual situation is still remembered in the name of No. 61 Greys Road, which is still called Barricadoes.

No. 33 Greys Road is adorned with a blue plaque commemorating Nelson Victor Carter of the 2nd (Southdowns) Battalion of the Royal Sussex Regiment. Nelson, who was born in Latimer Road, lived here. On 30 June 1916, Company Sergeant Major Carter led his men on an attack of the 6th German Army in what was to become known as the Battle of Boar's Head, one of the preparatory actions of the Battle of the Somme, which was to be launched on the following day. Under horrendously intense machine-gun fire, he led a fourth wave of men across no man's land to the German trenches, where he captured an enemy machine gun. As he returned to the British front line he assisted wounded soldiers, carrying one of them, but he was shot through the chest and killed. For his bravery, he was posthumously awarded the Victoria Cross. His grave at the Royal Irish Rifles graveyard in northern France is inscribed, 'The Cherished Flowers of France may fall, but honour will outlive them all.'

Barricadoes.

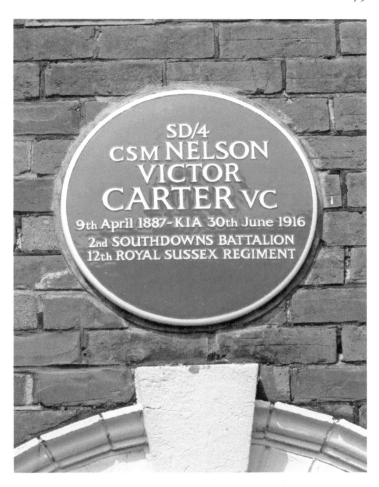

The blue plaque on
Greys Road.

The Heart of Eastbourne

Return to Borough Lane and walk down to the High Street. This crossroads, formed
by the High Street, Borough Lane and Ocklynge Road, is the true heart of Eastbourne.
This was probably one of the busiest places in the area. In the early 1800s a coach called
The Hero stopped at the Lamb on its regular runs between Brighton and Hastings. Indeed,
this crossroad was so busy that it was a fixed point for the Eastbourne Borough Police and
a small police lodge stood opposite the Lamb for many years.

Other buildings may have come and gone, but the parish church and the Lamb Inn have
been standing here for centuries. Although it was designated as a listed building in 1949,
the Lamb dates from the sixteenth century. It is almost certainly on the site of a former
inn, which possibly once belonged to the adjacent church; indeed, the front of the building
is actually in Ocklynge Road, facing the church. Alan Smith in his well-researched book
on Eastbourne pubs gives a full account of the history of the building and mentions the
cellars, which probably date to the thirteenth century. They are similar to the merchant's
undercroft (now called the Crypt) at Seaford, although as they are part of a working pub

Above: The Lamb.

Left: The Lamb's cellar – now whitewashed and full of beer!

the cellars under the Lamb are whitewashed. Serving a good pint of Harvey's Bitter and excellent food, the pub is usually crowded; however, if you do manage to find a quiet time the landlady may well allow you to view the cellars.

Secret Tunnels

Many visitors to the cellars under the Lamb Inn hope to see the entrance to the famous secret smugglers' tunnels. They are always disappointed, as there are none. As I mentioned in my book *Secret Seaford*, I doubt whether there are any secret smugglers' tunnels in the whole of Sussex. This view is contrary to popular local folklore, but there is absolutely no evidence of them. Personally, I believe that the rumour was probably started by the smugglers to fool the excisemen!

Over the years many respected local historians – including Fred Bridger, Lawrence Stevens and, more recently, Jo Seaman – have led teams of people to find these enigmatic underground passages but none have been found. In the 1970s I joined local archaeologists in the excavation at the Jesus House site opposite the church. The most asked question was 'Have you found the secret tunnels yet?' which became rather tedious.

In 2018, Jo Seaman of Eastbourne Council and his team investigated the tunnels. What many pointed out as the start of a secret tunnel at the Lamb was actually a double-decker garderobe – an early toilet! Sussex historian Mark Antony Lower wrote in 1858 'there is a tradition that the Lamb is connected by a subterraneous passage with the Old Parsonage, but although that edifice bears marks of high antiquity there is not the least ground for the tradition.' One hundred and sixty years later and the rumours persist.

DID YOU KNOW?

A lost cellar was uncovered under the Devonshire Park Theatre recently. It is believed to have been undisturbed since electricity was installed in 1903. The cellar contained the old gaslit 'In' and 'Out' signs for the entrance, a Burton's Beer advertising sign and, for some reason, a wrought-iron bedstead and a tin bath.

Lower also claimed that the Lamb was 'probably one of the oldest houses of entertainment in Sussex'. This is indeed true. The Lamb not only fed and watered its patrons, but provided them with amusements too. There was singing, plays and even magic shows. Auctions were held in the public rooms. Few people realise that Eastbourne once had a racecourse situated on the Downs between here and Beachy Head, and the Lamb Inn was the place where bets could be laid and winnings collected.

In 1785, Thomas Fuller, the landlord, advertised in the local papers:

EASTBOURN BALL
THOMAS FULLER at the Lamb Inn, Eastbourne, respectfully informs his Friends and the Public in general, that his BALLROOM will be opened on Monday the 11th July when

he will be extremely thankful for the Company of any Ladies and Gentlemen that will do him the Honour to attend. Mr Fuller flatters himself that his room is fitted up with some Degree of Taste and Elegance, and ventures to assure his Friends and the Public, that his Beds and Sleeping Rooms are good, convenient and comfortable and that no Pains will be spared to render every Thing pleasant and agreeable.

Note the two different spellings for Eastbourne and the liberal use of capital letters. In 1811, the Eastbourne Races coincided with a Grand Ball at the Lamb and the Grand Fair.

The Vigil and the Morrow

Many patrons of the Lamb would have come to Eastbourne to attend the weekly market that was held in the surrounding streets every Thursday. The market was first mentioned in the fourteenth century but had declined by the late eighteenth century. There were also two annual fairs.

St Matthew's Fair was granted to local landowner Bartholomew Badlesmere in 1314. It was a three-day event held on 'the Vigil, the Feast and Morrow' of St Matthew – usually 20, 21 and 22 September. It was a mainly agricultural event and the roads would be blocked with livestock, particularly hundreds of sheep ready to be sold. A few days later was the Old Town (or Michaelmas) Fair, held around the feast day of St Michael on 29 September. This was more of a pleasure fair.

Eastbourne Fair.

Ebenezer Remembers

Although I do not think my great-grandfather Ebenezer Roberts would agree with my religious views, I would have dearly loved to have spoken to him and asked him about Eastbourne of the past. I cannot do this, of course, but I have the next best thing. Shortly before he died in 1947 he wrote a brief account of his early life in an old red school exercise book. His shaky faint writing in pencil reveals many secrets of the past, including the annual fairs. He writes:

The Old Town Fair was one of the annual attractions. The vans, having arrived the previous evening, remained outside the churchyard wall in Church Street for the night. Early the next morning crowbars were at work and the booths and tables prepared with a good display of gingerbread and sweets etc. One booth was erected by a local confectioner by the name of Vine. The Sheep Fair was held on various plots of ground, usually the gardens of St Mary's Institution. Both fairs were looked forward to with exceptional annual interest by the inhabitants of Eastbourne.

Ebenezer gives a fascinating account of life in Old Town and the people who lived there. He first tells us about his mother (Hannah) and himself:

My mother was born in 1828 in a cottage that was at the rear of Boulder Cottages, near the barn where the Artillery used to drill with the farm lodge at the rear, butting on to watermill pond.' (This area is now The Goffs) 'I was born at Pillory Bank, Church Street, Old Town on 25th August 1867. The cottage stood at the bottom of what is now the Artizan's Dwellings.

I have not been able to trace this building, but it was probably to the west of the church in the area of Bradford Street.

He tells of his days at Miss Brodie's School and how the school fees depended on how many children there were in the family. He was taught 'elementary subjects' such as mental arithmetic, religious subjects and drill, which was provided by an ex-soldier. The penalty for not performing drill properly was to stand in the playground holding a stone in the right hand and holding the left leg up with the left hand. This seems to be a particularly harsh punishment for a young schoolboy, but there was still fun to be had: he remembered sliding over the frozen watermill pond and playing with his friends in the South Field, which had a footpath leading to Grove Road (now a busy road).

It is clear that many of the families in Old Town were poor, so the school established a clothing club. A few coins were paid at the school every Saturday evening. The money was collected by the vicar and his wife and my great-grandfather remembers that 'at the end of the year, Miss Bird would sign forms with a quill pen for the various drapers in the town to supply the goods according to the values of the accounts received. The parcels of drapery were then taken to the Vicarage and left open for inspection before being received by the owners [to make clothes for the children]'.

Ebenezer goes on to mention the Old Town tradesmen, doctors, celebrities (the gentry), the military and the local politicians. I am so lucky to have such a record.

My great-grandfather Ebenezer Roberts and his wife Bessie on their wedding day.

We are Robbed!

Hidden behind the noticeboard in the churchyard of St Mary's, just opposite the Lamb, is an unusual but brilliantly decorated Cornish cross. The cross was kidnapped from its home and brought here 200 years ago.

The culprit was Davies Giddy who lived at Tredrea, St Erth, near Hayle in Cornwall and was the curate of St Erth Church. Born in 1767, he had an interest in astronomy, mathematics and engineering. He was friends to people like Humphrey Davy, Thomas Telford and Richard Trevithic and was interested in using steam power to run railway trains.

Giddy became the high sheriff of Cornwall and served as the MP for Bodmin from 1806 until 1832. He fell in love with Mary Jane Gilbert, the only child of the family who owned the Manor House in Eastbourne, and after they married on 18 April 1808, he agreed to take her name. They lived at the Manor House (later the Towner Art Gallery) in Cornwall, and also in London, where he stayed to be close to Parliament.

Eastbourne's Cornish cross.

Gilbert seemed to be an effective MP. He campaigned for the abolition of tax on salt in order to help the fishermen of Padstow. He also chose Isambard Kingdom Brunel as the designer of the famous Clifton Suspension Bridge. He was a keen geologist and antiquarian, and was particularly interested in the long history of Cornwall. He wrote a four-volume history of the county and even wrote books in the Cornish language. He was the president of the prestigious Royal Society in London.

With this background, it is surprising that he chose to uproot a symbol of ancient Cornwall and move it to Sussex. Gilbert had noticed an old Cornish cross just off the road between Truro and Redruth in the parish of Kenwyn. The large cross, around 8 feet tall was being used as a gatepost. He thought that the ancient relic needed to be rescued and originally was going to take it to his home in Tredrea. His relative John Giddy arranged with the farmer for the removal of the cross and for a proper gate post to be built in its place.

The cross was probably taken to Tredrea where Gilbert changed his mind and decided that it would be better to re-erect it 300 miles away at his home in Eastbourne. The cross

was taken to London by road and then sent by sea to Hastings and it finished its trip by road again. On 10 December 1817 Colonel Ellicomb of the Eastbourne Royal Engineers assisted Gilbert in erecting the cross in the grounds of the Manor House (now Manor Gardens) by using an 'artillery triangle fall block'. Sadly, it is likely that this wonderful cross was seen by less people here than when it was beside the road near Truro.

Giddy was once asked by a Cornish friend, the Reverend-Canon Hockin of Phillack, why he had taken the stone from Cornwall. He replied that the poor ignorant folk of Sussex needed to be shown that there was something bigger in the world than flint. The vicar replied, 'We are robbed!'

The stone stood behind the walls of the Manor House for many years and in 1890 the Cornish historian Arthur Langdon visited Eastbourne to inspect the stone. He was writing a book on Cornish crosses and, although he had listed and illustrated dozens of examples, thought that the one at Eastbourne was particularly fine. He made a detailed report, which included fine drawings. He said that there were only seven of a similar design, but the Eastbourne cross was the most ornate of all. He records that the cross was 8 feet 2 inches tall and made of elvan, a hard granite-like Cornish stone. As for a date, Langdon says the cross is 'early', but it has been since dated to the tenth century.

Arthur Langdon's drawings of the cross.

In July 1895, the Sussex Archaeological Society visited Eastbourne as guests of the Duke of Devonshire. They visited the Town Hall, St Mary's Church and those cellars under the Lamb Inn. They then went to inspect the Cornish cross in the Manor Gardens. It seems that a short time later – certainly by 1902 – the cross was removed to its present position

The *Eastbourne Pagan Circle* report that the cross is 'obviously phallic', which is clearly not the case; however, I do agree with their statement that the disc face does not actually bear a conventional Christian cross. They report that some form of survey of the cross was completed by a Pagan historian called Colin Murray in 1975. He concluded that cross was a 'megalithic measuring stone'. Whether it is a Christian cross or a Pagan megalith, it is clear that centuries ago it served some important purpose. It was either revered itself, marked an important place of worship or had some secret ritual use that we have now forgotten.

The cross is still in a good condition, although sadly it is now hidden behind the church noticeboard so no longer really visible from the road.

St Mary's Church

The long history of the church has often been investigated, particularly by Revd Walter Budgen, whose lengthy book *Old Eastbourne, its Church, its Clergy and its People* of 1912 covers every aspect of the church. A good modern guide is available to buy. Of particular interest are the Easter sepulchre to the left of the altar, used to symbolise the tomb of Christ, and the memorial to Henry Lushington. The memorial gives a full account of his unhappy service with the East India Company, surviving the stifling heat of the Black Hole of Calcutta only to be murdered a few years later.

Budgen mentions various mason's marks in the church. Today we would describe these marks as church graffiti, but their origin and meaning is obscure. There are dozens of depictions of fish on ancient stones, often in out of the way places. The fish are not the early Christian ichthus, but appear to be real depictions of fish with fins and mouths. Budgen contends that they are the work of a single mason called 'Fisher', but I doubt if this the case. Being so close to the sea, I personally think that the fish were scratched by fishermen to give thanks for a good catch. Alternatively, they could have been requests for divine help for one.

Most of the graffiti in St Mary's Church is difficult to see without powerful lamps and specialist equipment. I have joined a small but enthusiastic team who hope to record the graffiti here and at other local churches over the coming months.

Take a quick look at the pillar closest to the exit on the north side of the church (opposite the main entrance) where you can see a series of interconnected circles. It is likely that they were scratched through paintwork so would have once stood out more clearly than they appear now. There is evidence that, prior to the Reformation, these pillars and the walls would have once been painted.

These marks must once have had a meaning and, as they were not removed, were probably made with the full knowledge and support of the clergy. What they represent will remain a secret.

St Mary's Church with a borough policeman.

DID YOU KNOW?
In 1836, a child was brought to St Mary's Church for baptism. The father, William Wood, proposed to call the boy Chaney, which was his was of pronouncing the word 'China'. The vicar, Revd Pitman, refused and told the father to go away and think of another name. The new name of Bird was accepted as it was the vicar's wife's maiden name!

Have You an Old Football?

When you leave the church via the north door you will pass through a corridor that connects to the old sixteenth-century parsonage. On either side are the names of the fallen of the world wars. Every name has a story behind it, but not every person died in the heat of battle. On the memorial you will find the name of John Tosswill.

John (known as Jack) was born in Eastbourne and lived at No. 59 Victoria Drive. He was a talented all-round sportsman. He started playing for Tunbridge Wells FC then Maidstone FC before joining Queens Park Rangers as a professional footballer. He soon came to the notice of and transferred to Liverpool FC. He played in eleven matches for

Liverpool scoring one goal. He later played for Southend FC and finally Coventry City FC where he played seventeen times in the 1914–15 season.

Jack was deaf, which led to some amusing moments as he couldn't hear the referee's whistle and on several occasions kicked the ball into the goal when play had been stopped for a foul. In July 1914, just a few days before the outbreak of war, he played cricket for Eastbourne against an Essex side, making 122 runs. He joined the motorcycle section of the Royal Engineers and went to Biggleswade for training. His call up was reported in the local Coventry newspapers. The *Liverpool Echo* of 28 January 1915 reported:

> You will remember our forward Tosswill who went to Coventry. He is now to be found in the Royal Engineers at Bedford where he is in the motor section. Tosswill says he is having the time of his life. 'We have not the care in the world in this camp. I should like to be remembered to all my Liverpool friends. I should like to see the team a bit higher in the League but no doubt they will begin to climb shortly. With all good wishes – P.S. Have you an old football?

Jack Tosswill.

Jack was taken ill while posted to Southampton and returned to Sussex, but died in the Eastern General Hospital in Brighton as a result of an operation. An obituary in the *Coventry Telegraph* on 4 October 1915 reported: 'He played as a forward and was rather eccentric in his game but was at times capable of showing flashes of real brilliance and was a useful goal getter. He was a well-educated and gentlemanly young man with an agreeable disposition.'

The Start and the End

Leaving the church, turn left and walk between the graves into Church Lane, which leads into Parsonage Lane. A green gate on your right will lead you into the delightful Motcombe Gardens, the start of the Bourne stream, which gave Eastbourne its name, and marks the end of our long perambulation.

Although peaceful today, there was once a duck decoy here to allow the wildlife in the pond to be shot from behind a wall near the bowling club. The pond is in fact a spring and the source of the Bourne stream, which is now mainly culverted on its journey to the sea; however, it can still be heard under some drain grills if you know where to look (or rather listen).

Nearby there are shops, a couple of good pubs, cafés, the delightful Motcombe Baths and the former home of comedian Tommy Cooper (decorated with his likeness) all in the former lands of Motcombe Farm. Motcombe Farm once had a fine flock of Southdown sheep, which were much sought after by breeders. Most of the Motcombe farm buildings were demolished in 1909, but the splendid circular flint dovecote was saved.

It is probable that the Normans introduced doves to England as there are dovecotes built into Norman castles such as the one at Rochester. Dovecotes were a practical way of keeping birds for food throughout the year and were built all over the UK. Indeed, by the seventeenth century there is believed to have been around 26,000 dovecotes in England alone. This one at Motcombe was first mentioned in the 1300s.

The birds here, however, would probably be rock doves (*columba livia*), also known as the common or garden pigeon, and the unfledged young were known as squabs. Squabs were a delicious treat for our medieval ancestors. They could be skewered and roasted on an open fire and because their bones were soft, they could be eaten whole (much like a sardine). The pigeon's eggs could also be eaten, therefore the building was basically an all-year-round larder. To gain access to every pigeonhole, a centrally based revolving ladder called a potence was used. (A potence is also an alternative name for a gallows; the potence at nearby West Dean dovecote has been reconstructed.)

As well as food, there was another byproduct of the dovecote: pigeon droppings (guano). The floor of the dovecote would have been covered with 2 or 3 feet of pigeon droppings. Guano would have to be cleared regularly but would have been used to fertilise crops, as it is an important source of nitrates.

I have been lucky to have been inside the dovecote to see the rows of nest holes, some rather poorly renovated. In March 2018, a small group of local archaeologists excavated around the base of the building and found a horse trough. How wonderful that secrets of Eastbourne are still being uncovered!

The Motcombe Dovecote.

The Dovecote interior.

Why are the Horses Tired?

Although I am sceptical of secret smugglers tunnels, I am certain that smuggling was rife in the Eastbourne area as this (true) story will illustrate.

Mr Longshaw was well off and in the 1830s hired a house in Eastbourne for the summer season. He owned a phaeton – a large open carriage with large wheels – and four fine carriage horses to provide the horsepower.

After a few weeks it was noticed that the horses were sluggish and at times so ill that they were unable to pull the carriage. On one Sunday morning they ground to a halt and stopped en route to the parish church.

Mr Longshaw asked his grooms to change the horses' food and oats. Chopped hay and various beans were used with no change in their health. Being a wealthy man, he hired a veterinary who applied bandages to their feet and even took them bathing in the sea, but there was no change. The once fine animals were always tired and listless and no one seemed to know why – maybe it was a mystery illness?

Poor Mr Longshaw was at his wits' end and thought it would be prudent to sell the poor horses, although would only make a fraction of their previous worth. But help came

from an unusual source, not a vet but the lieutenant who supervised the Eastbourne section of the Coastal Brigade – the government troops established to patrol the coast for French privateers (pirate ships) and smugglers. He noticed that Mr Longshaw's coachman seemed to be rather friendly with George Hatherington, a suspected local 'fair-trader' (smuggler).

The lieutenant questioned the coachman – I cannot imagine the interview was very subtle – and he confessed to hiring out the horses most evenings to Hatherington for £1 a night. The poor horses were worked hard all night before being returned to Mr Longshaw's stables just before daybreak. In fact, it was admitted that the night before the interview, the horses had been used to land a cargo of contraband foreign spirits on the beach at Seaford. The Seaford Coastal Brigade had nearly caught them and Hatherington had only escaped by whipping the heavily burdened horses to swim across the Cuckmere River.

Mr Longshaw was unsurprisingly 'astonished and indignant' at hearing the news and I am sure the offending coachman was sacked on the spot. One hopes that the poor horses soon regained their health. Working a day and a night shift, it is no wonder they were tired!

Smugglers.

Bibliography

I have used a variety of sources for this book including the following:

Budgen, Walter, *Old Eastbourne* (1912).
Chambers, George, *Eastbourne Memories* (1910).
Chambers, George, *Handbook for Visitors to East-Bourne* (1868).
Cooper, Robert, *Reminiscences of Eastbourne* (1903).
Eastbourne's Historic Street Furniture (ELHS: 1984).
Graham, Reginald, *Eastbourne Recollections* (1888).
Hide, Ted, *The Pleasure Boat Men of Eastbourne* (2007).
Roberts, Ebenezer, 'A Short Account of My Life' (1947).
Salvation Army, *Marching with Music* (1963).
Smith, Alan, *Public Houses in Eastbourne* (2017).
Stevens, Lawrence, *Some Windmill sites in Friston and Eastbourne* (1982).
Stevens, Lawrence, *The Vigil and the Morrow* (1980).
Stevens, Lawrence & Gilbert, Richard, *The Eastbourne Roman Villa* (1973).
Street Names of Eastbourne (ELHS: 1973).
Summerdown Camp Journals (1916).
Sussex Archaeological Collections.

Eastbourne Herald, Eastbourne Gazette, Sussex Weekly Advertiser and other newspapers sourced via the National Newspaper Archives.

Acknowledgements

Jo Seaman and Katherine Buckland, Heritage Department, Eastbourne Town Council.
Shirley Moth of the Friends of the Wish Tower.
Mick Hymans and Russell Owen of Eastbourne Local History Society.
The Eastbourne Society.
Eastbourne Library.
The National Archives, Kew.
David Taylor for his illustration on page 93.

About the Author

Kevin is a retired British Transport Police officer with a lifelong interest in Sussex history. He provides occasional guided walks and illustrated talks on a variety of local history subjects. Further details can be found at www.sussexhistory.net.